Life Drawing

Michael Woods

Life Drawing

Dover Publications Inc., New York

DEDICATION

To Vanessa, David and Alex

ACKNOWLEDGMENT

I would like to thank all the models –
and in particular Frank Guppy – who
have stood, sat, and, against many
odds, maintained their pose so that
others might draw. In checking and
typing the manuscript my wife has
been invaluable

© Michael Woods 1987
First published in Great Britain 1987
by Dryad Press Ltd

Printed and bound in Great Britain

Library of Congress Cataloguing in Publication Data

Woods, Michael.
 [Starting life drawing]
 Life Drawing/Michael Woods.
 p. om.
 Reprint. Originally published: Starting life drawing. London:
Dryad Press. 1987.
 Bibliography: p.
 Includes index.
 ISBN 0-486-25885-8 (pbk.)
 1. Human figure in art. 2. Drawing – Technique. I Title.
NC765. WBB 1988
749', 4 – – dd 18

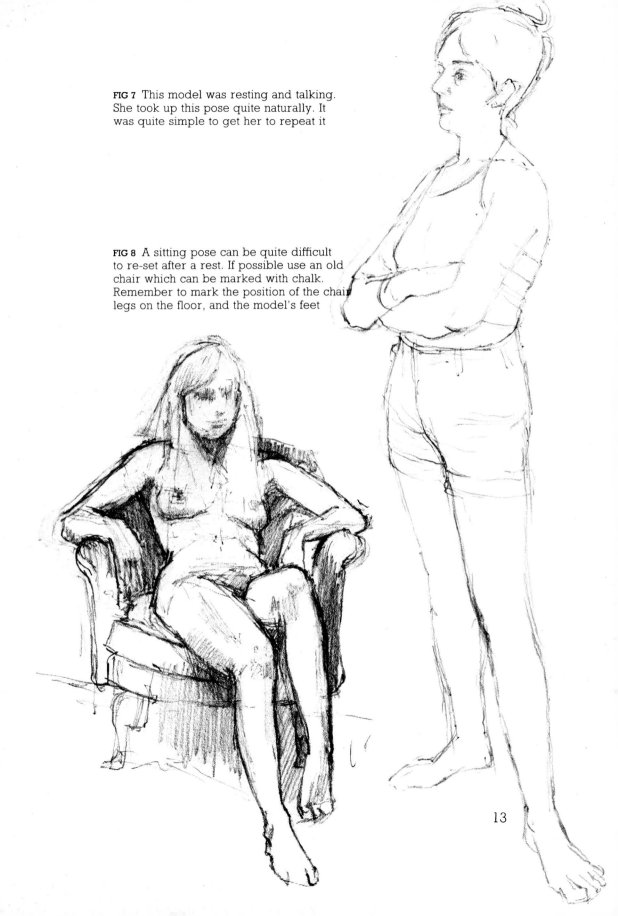

FIG 7 This model was resting and talking. She took up this pose quite naturally. It was quite simple to get her to repeat it

FIG 8 A sitting pose can be quite difficult to re-set after a rest. If possible use an old chair which can be marked with chalk. Remember to mark the position of the chair legs on the floor, and the model's feet

13

CHAPTER 2

The whole figure

Bodies are long, rather thin things with a blob at the top and some side pieces which fray out at the ends (Fig 9). The parts can lean this way and that and some can be out of sight altogether. For the artist this rather unsympathetic portrayal is nevertheless preferable to one which may describe a person as 'rather handsome with piercing blue eyes and a charming manner'. We have such strong ideas about what we think people are like that I must stress that one must endeavour to look impartially at the figure. Think of the whole body as a map and try to compare patch with patch – the shapes and angles are really the most important elements.

There are some crucial factors which you should consider when viewing the figure in front of you. If you had to put one single line through the whole figure, what angle would it make with an imaginary vertical line? This vertical line and its companion horizontal line are basic absolutes by which you can consider everything else.

Use a long pencil and hold it vertically in front of your view. Turn it to a horizontal position and consider how the parts of the figure relate to one or the other. Figures 10 and 11 illustrate a seated figure. So what single line would you choose for your particular model? This is not the vague consideration it may sound because the whole attitude of the figure sitting in a chair may well be much more sloping than you would first suppose. The problem is that we tend to think of bodies as upright things.

Legs are very long. Although the inside dimension of the leg accounts for roughly half the total height of the figure, the leg on the outside can sometimes appear to start at the hips (Figs 12 and 13). If you err at all, it will probably be to make them too short. Test this by using your pencil again, but in a different way. Use it as a measure. With your arm fully stretched out in front of you towards the sitter, so that the measured dimensions are constant, line up the blunt end with the top of the head. Move your thumb to a point on the pencil which corresponds to the waist of the person. Move your whole hand with pencil down so that the blunt end now lines up with the waist and note what your thumb lines up with. Once again I predict that you will not have come to

14

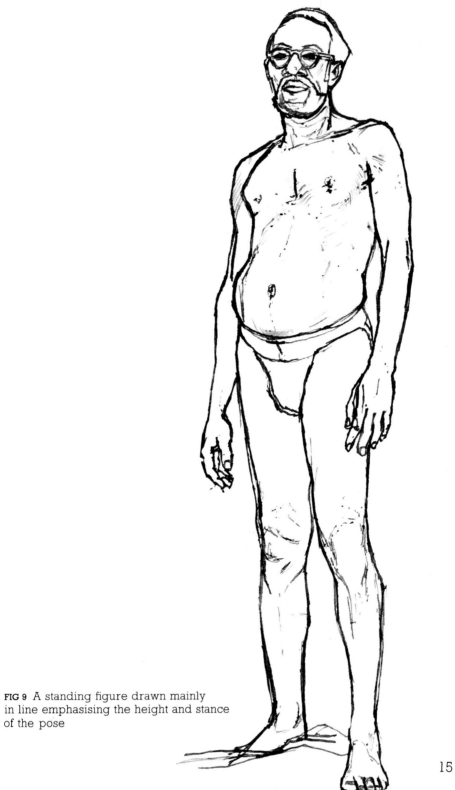

FIG 9 A standing figure drawn mainly
in line emphasising the height and stance
of the pose

15

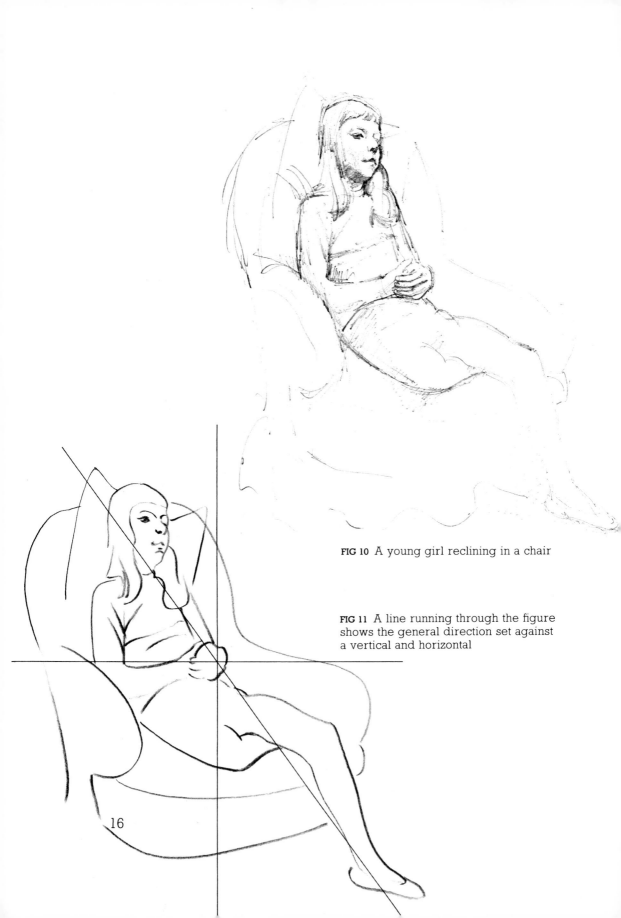

FIG 10 A young girl reclining in a chair

FIG 11 A line running through the figure
shows the general direction set against
a vertical and horizontal

16

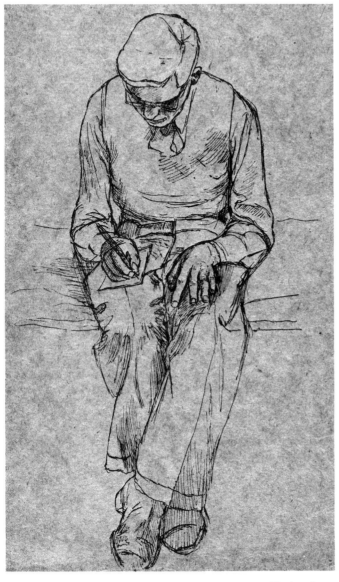

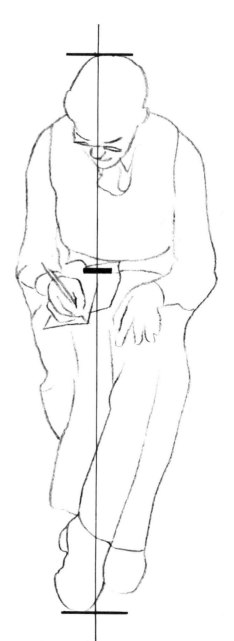

FIG 12 A friend writing a letter. Notice the proportion from the top of the head to the waist compared with the waist to the shoes

FIG 13 This simplified diagram of the subject in Fig 12 shows more clearly the greater length of waist to toe

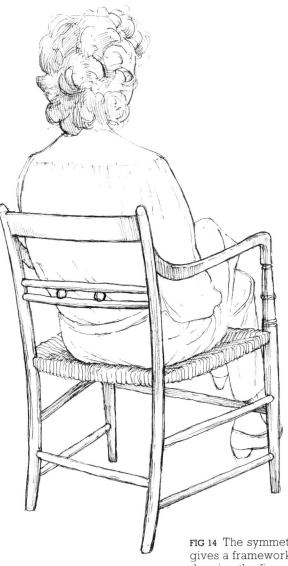

FIG 14 The symmetrical shape of a chair gives a framework which is helpful in drawing the figure

the end of the figure. The legs, likely to be coming towards you, will appear to be comparatively bigger, and therefore longer.

The chair in which the figure sits is also of enormous help. Select an upright dining-room chair. This is suitable because of its symmetrical form (Fig 14). The chair's four legs rest on the ground, the seat has similar sides, a front and a back; the arms, if there are any, will be of the same size and opposite one another, while the back has cross members, linking both sides, which are also symmetrical. This is a sort of perspective framework which surrounds the subject, and by similarities or by contrast can help to place the figure in space.

How much space to leave around a figure is always a difficult problem. Too little and the result looks cramped, too much and the figure looks lonely and a bit lost. The examples (Figs 15 to 18) show something of the variety. Whichever way the figure looks, allow more space on that side. Don't get the head too near the top and don't run out of space under the feet or they will look as if they are 'walking' on the edge of the drawing.

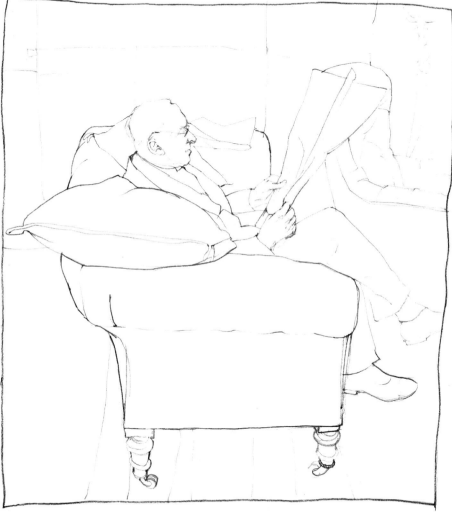

FIG 15 The area occupied by the gentleman reading a newspaper is quite a small part of the whole area of the drawing. But all that surrounds the figure gives the reason for the figure being in that particular pose and seemingly comfortable

19

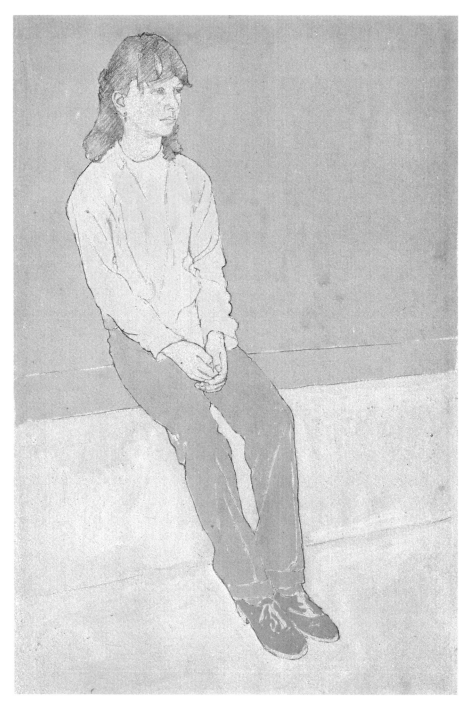

FIG 16 A young girl posing in an art class. The space surrounding the figure seemed necessary to emphasise the long slim forms. It was drawn in pencil on fawn paper and then coats of thin poster paint applied in patches nearly up to the line to make slight tonal variations

20

FIG 17 The girl's umbrella creates the width
of the drawing; the space beneath it seems a
natural result

21

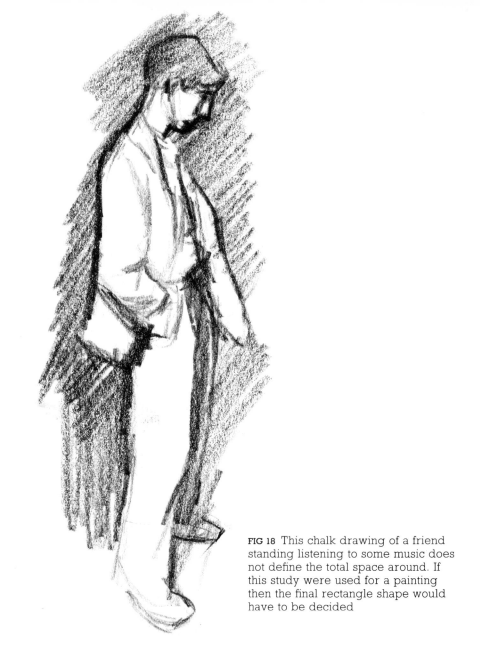

FIG 18 This chalk drawing of a friend standing listening to some music does not define the total space around. If this study were used for a painting then the final rectangle shape would have to be decided

But by far the most important consideration is the overall physical characteristic of the subject. I suppose the cartoonist holds on to and develops this characteristic the most clearly. And although this emphasis is immediately recognisable it takes the characteristic to the extreme – to a point of distortion – and we have no doubt as to what point is being made. The artist does not go this far. I do not advocate distortion, but rather the conscious maintenance of the basic characteristic. Thus if the person is a very fat man with dark hair wearing a very white apron, then that is just what one describes. He will not be a lean man, with grey hair, in a grey apron.

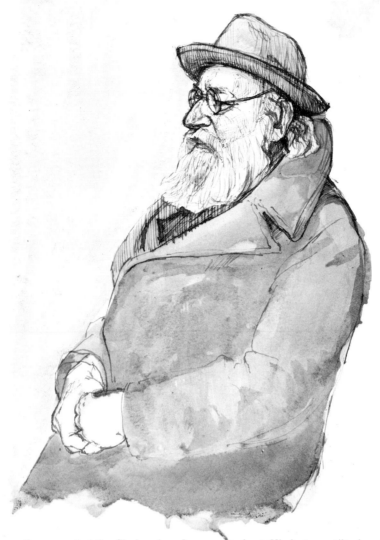

FIG 19 This gentleman sat at the Slade when I was a student. His hat was tilted well back, and his coat had a large collar which met the rim at the back. The effect of the thick heavy material of the coat, probably over several other layers, gave a 'full' look to the torso. His flowing beard was very much part of the whole head and not an addition

Helping art students has taught me to expect that most of the main characteristics of a model are likely to be muted in the hands of the less experienced. Therefore try to make a particular point of describing the main features – those which are most important – rather emphatically (Fig 19).

Although words are not the tools of the artist, a conscious mental description can help nevertheless to clarify the brain and eye. When the brain has sorted out the problems, the hand will find it a much easier task to implement those thoughts. However much we wish to draw well, it will not just happen. The pianist creates a specific sound by a combination of specific notes. For the artist these notes become length and direction of lines.

CHAPTER 3

The nude

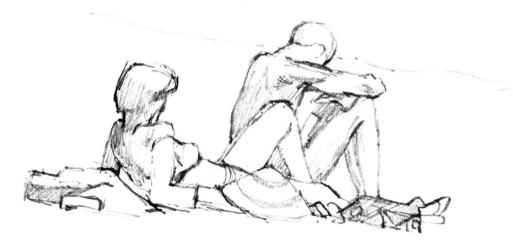

FIG 20 A couple viewed from behind, sunbathing on a beach

Drawing people on the beach when they are wearing minimal clothing can well be the first time that drawings are made without the camouflage that normal clothes make (Fig 20). However, when people are close enough to be viewed clearly, they can become rather irritated if peered at. Groups further away can make fascinating study, for they are totally natural in their arrangement and poses. But for the less experienced, the speed of drawing needed can be daunting, because even when sunbathing we turn and change position surprisingly often. However it does give excellent experience in judging proportions quickly, and for this purpose line alone is probably quite enough (Figs 21 to 23).

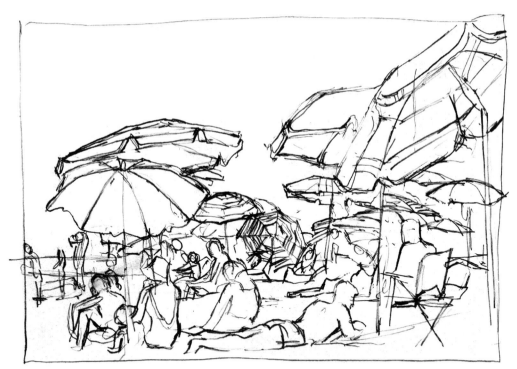

FIG 21 The jumble of sunshades and figures on an Italian beach. The density was so great that no-one noticed the study being made

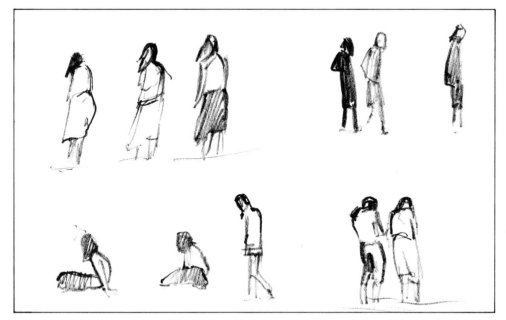

FIG 22 Figures walking along a shoreline in a cool wind

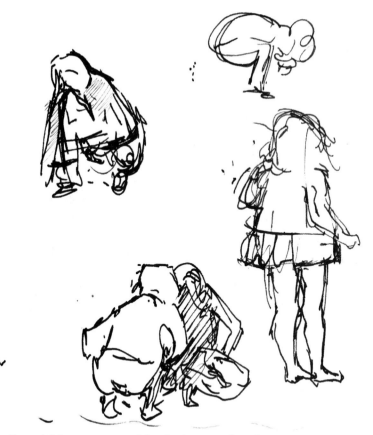

FIG 23 Two children engrossed in playing on a beach

When the sunlight is strong, the shadows cast can give a valuable three-dimensional aid. Try to think of the patches the shapes make and follow these thoughts with shading (Figs 24 and 25).

For all the thoughts that the unclad figure is complicated and only for the professional, I have always found that students prefer the overall simplicity which the nude provides. Once any initial embarrassment is past, the wonderful and ever-rewarding, ever-changing forms are there to be sought. I have chosen this word intentionally for the great complexity of the human form precludes copy. Somehow one has to sum up the proportions, the directions, the whole pose (Fig 26).

You may be able to persuade a member of your family or close friend to pose for you, or, if you are lucky, to join a class working from a nude model. Both will add to your experience, but a stranger will be neutral, and much less likely to offer comment. Not that comment is not permitted, but when you are beginning it can be very refreshing not to feel guilty when the model looks at your efforts. So, creating the best circumstances possible, try several drawings, each giving a different emphasis to your thoughts.

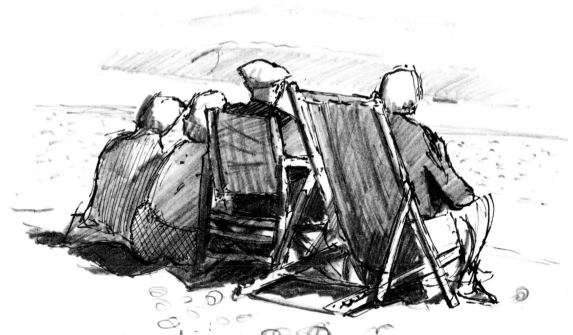

FIG 24 A group of older people on a beach enjoying the sun. First drawn with pen, the addition of pencil developed the tone of the shadows which fused the group together

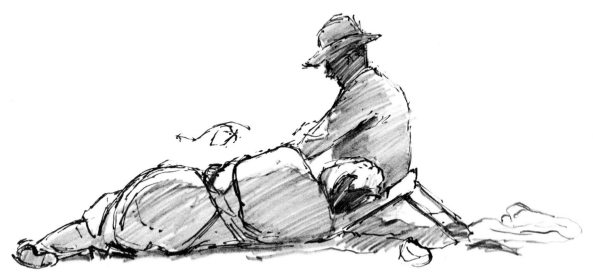

FIG 25 The pencil shading of the man helps to show the light on the reclining lady's head: line alone would not have revealed this

27

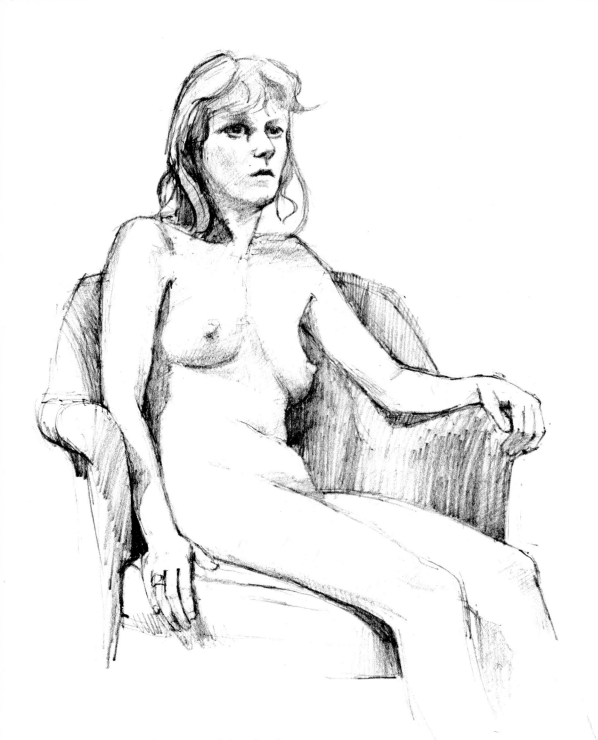

FIG 26 A young model posing for a
drawing class. The nude presents a simplicity
of form which clothes often complicate

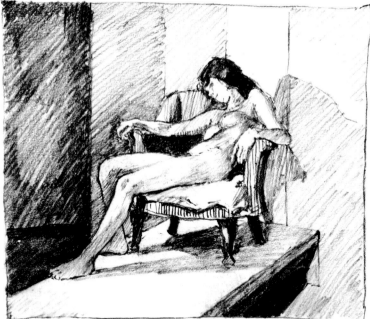

FIG 27 A nude reclining in a chair. The direction of the whole pose – made up of all the limbs and proportions – has to be considered

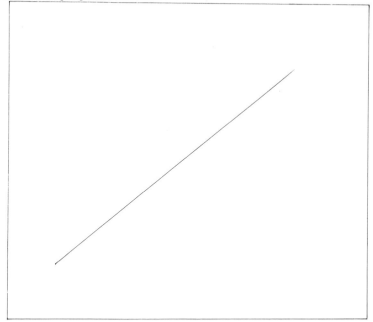

FIG 28 This single diagonal line represents what could be considered the general direction of the pose of the model in Fig 27. This overall direction must be maintained while drawing the individual parts

A first drawing could be the single pencil line discussed in the second chapter. If you are able to choose one basic directional straight line and dare just to put it down on the sheet of paper, you will have summed up one of the greatest tasks, that is to judge the angle of the pose (Fig 27). Of course parts of the figure may lie this way and that, but ignore these individual changes and just sum up one main direction (Fig 28).

Put this paper with its single line on one side and start again on a fresh sheet. Repeat this line, very faintly this time. As best you can, draw your figure, but at all costs maintain this overall direction within the body and limbs and try to avoid making this sort of drawing a portrait.

The girl in Figure 29 has a near vertical stance. For this sort of pose, try starting with the base of the neck, the top of the manubrium marked with a + in Figure 30. From here the collar bones run out at both sides, the neck grows upwards and the centre line of the construction of the rib cage drops down. Notice that this is not necessarily the centre line of the actual drawing. Decide if the shoulders are at different heights. In Figure 30 the right-hand side is lower than the left. Consider the area of the chest, what sort of rough rectangle it makes. Again (using Figure 30 as a guide) consider the distances; the highest shoulder to the nipple and the nipple to the navel. In this particular case they are equal. So are the distances from the top of the head to the nipple and the nipple to the hand.

Consider how much larger the distance is from the left-hand elbow to the navel and from there to the boundary of the right arm. These are the sort of judgements which have to be made, but of course in each pose they will differ. There are no absolute dimensions.

One major advantage of drawing from the nude is that all the parts stay pretty well the same, as long as the actual pose is maintained. Clothes fold in varying ways, tensions change, bulges appear where none were there before. Loose or knitted clothes only touch the figure in a few places. In contrast the nude figure is calm and clear – it is not surprising therefore that the artist has chosen to work from nude models so frequently.

FIG 29 A standing pose which involves some basic considerations shown in the diagramatic version (Fig 30)

FIG 30 Start at the base of the neck marked +. The shoulders are not at the same height (B and C); the chest is a sort of rectangle (D). A to F equals F to H; E to F equals F to G. These are just some of the considerations which have to be made. Of course for different views of each pose all the dimensions will vary

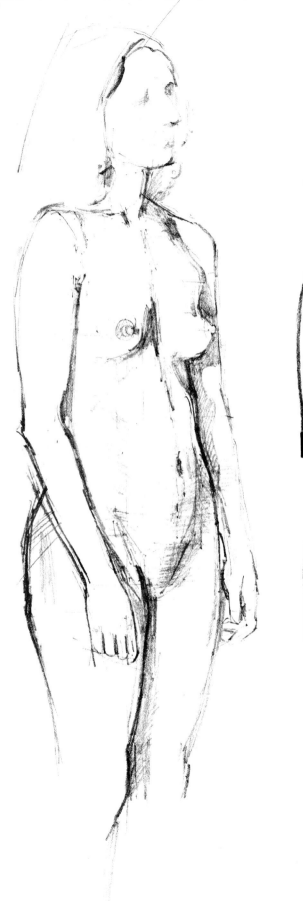

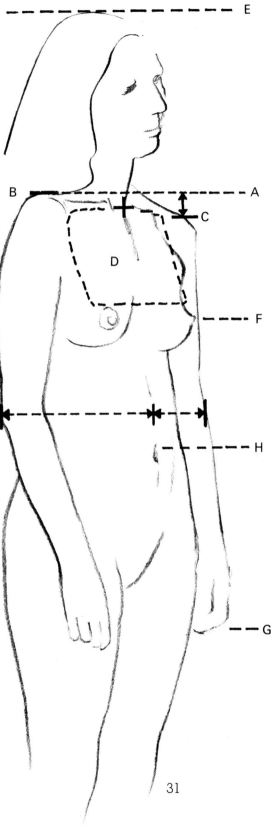

E

B ———— A

C

D

F

H

G

31

CHAPTER 4

Proportions

As a drawing gets under way, it is inevitable that changes in the assessment of proportion will take place. Changing a drawing is important and although when beginning to draw the removal of incorrect lines will seem natural, as experience grows I do recommend that most lines are left in, for their accumulative effect can distil out into a very satisfactory description (Fig 31). Models do move and settle in their pose, so modifications are natural and show the progress of the drawing.

To scribble is, generally, a term of some derision, yet for another drawing I suggest that the figure is described by marks made like those shown in Figure 32. Flit from side to side and top to toe, middle to side, to each and every noticeable feature in your view. Start very lightly, but as the marks begin to cover the whole area of the figure, return to the same points again and again, the drawing overall getting darker and blacker as you correct and re-correct the placings and proportions in front of you without using a rubber. One of the qualities of ink is that once made, the lines are virtually permanent, and therefore limit removal.

The absence of a single precise line is valuable for some of the early practice drawings. The pencil, a soft grade 4 or 6B, is ideal as it demands so little attention for itself, allowing all priorities to be given to the subject and the lines made. It will, however, almost certainly require re-sharpening.

Now try a line drawing. Use an eraser as frequently as you wish to remove unwanted lines. Using a pose similar to that in Figure 33, give as much attention to the shapes between the limbs as the limbs themselves. Compare the widths, some equal, some double, and again extend this comparison to the upper and lower parts of the figure.

Another type of drawing is one which seeks to become aware of the parts of the figure which are closer and larger, and those which are on the far side and may appear to have smaller dimensions, and be partially obscured. The nude in Figure 34 is sitting in a roughly symmetrical position, but seen here from one side. Pose your model in a similar way and notice the comparisons given emphasis in Figure 35.

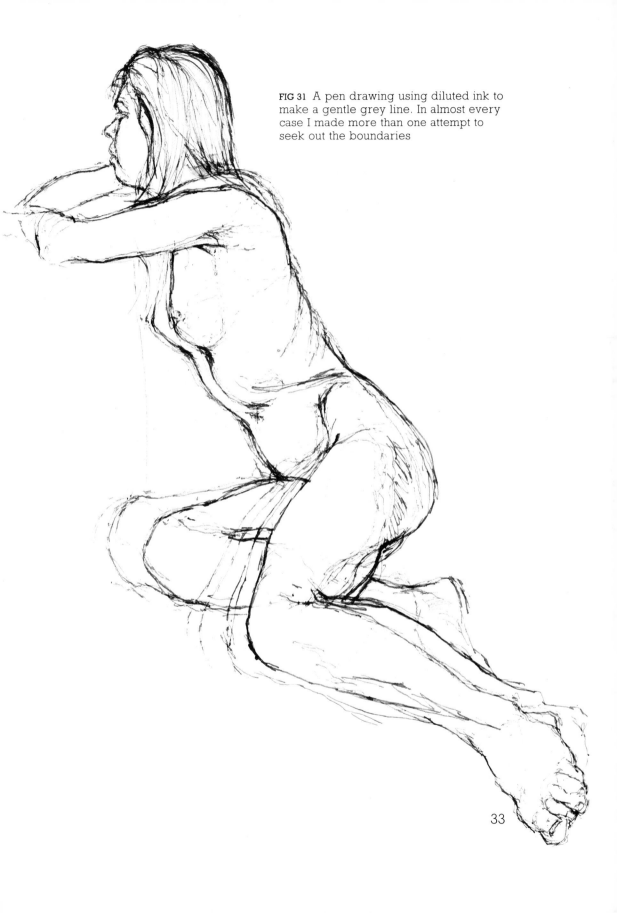

FIG 31 A pen drawing using diluted ink to make a gentle grey line. In almost every case I made more than one attempt to seek out the boundaries

33

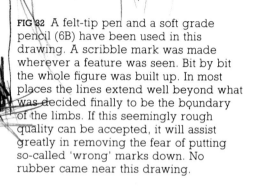

FIG 32 A felt-tip pen and a soft grade
pencil (6B) have been used in this
drawing. A scribble mark was made
wherever a feature was seen. Bit by bit
the whole figure was built up. In most
places the lines extend well beyond what
was decided finally to be the boundary
of the limbs. If this seemingly rough
quality can be accepted, it will assist
greatly in removing the fear of putting
so-called 'wrong' marks down. No
rubber came near this drawing.

FIG 33 A figure drawn with an emphasis on the outline boundaries. Only a little shading has been added to model slightly the forms. Most attention was given to the patches between the lines, the spaces between the arms and legs and the shape of the air itself round the figure. Strangely the proportions of the drawing can suffer if too much thought is given to one's conception of the actual person

35

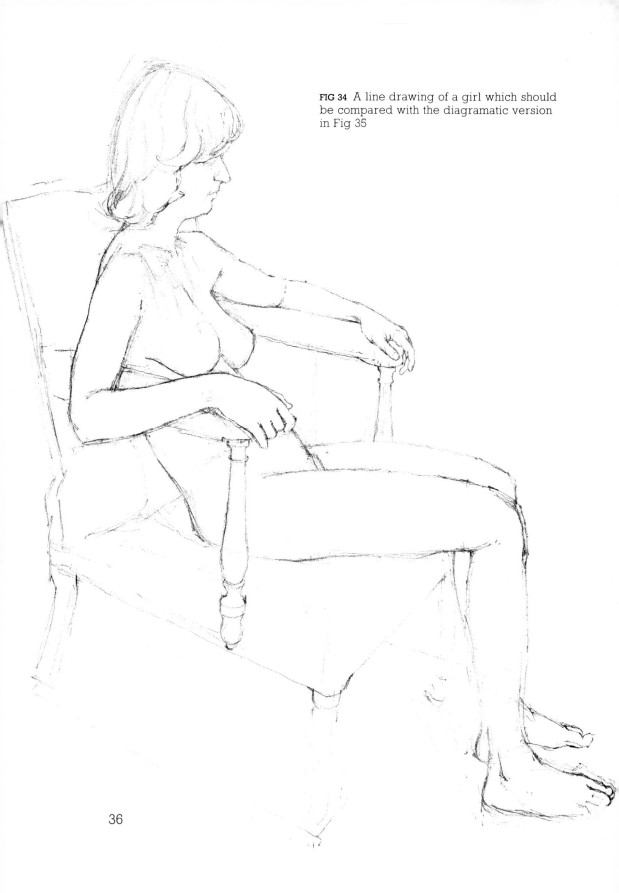

FIG 34 A line drawing of a girl which should be compared with the diagramatic version in Fig 35

36

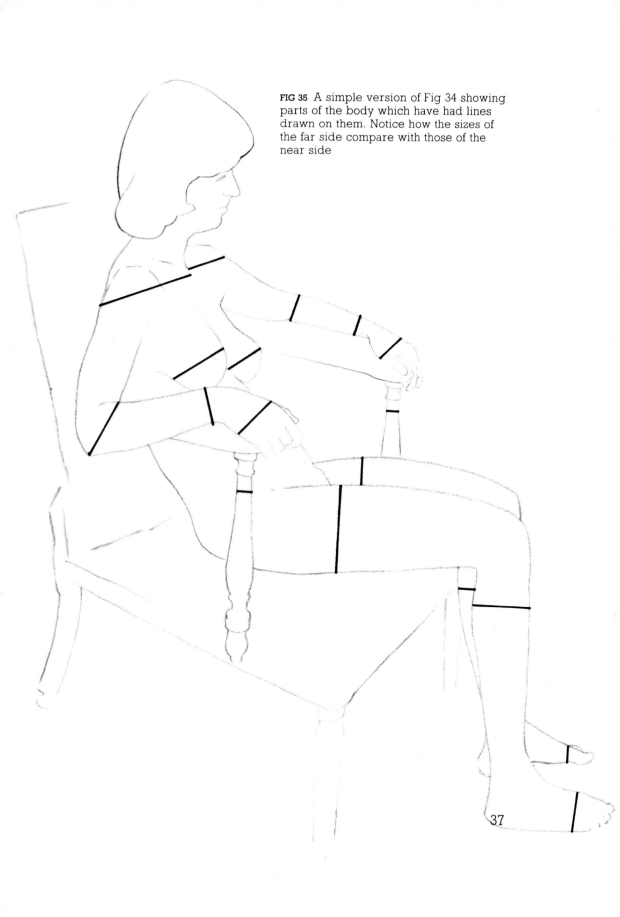

FIG 35 A simple version of Fig 34 showing parts of the body which have had lines drawn on them. Notice how the sizes of the far side compare with those of the near side

37

FIG 36 The simplest of line drawings with very few details. The overall quality depends only upon the judgement of proportions

There are some distortions which you can guard against, lest they creep up on you. The head drawn too large; the legs drawn too short; the far side of the figure drawn too big; a slanting pose drawn too upright. If you notice an incorrect line or proportion early on in a drawing, do correct it, but if you are towards the end of a pose, then I would recommend not doing so, because some qualities will be sound even if others are not. Note where you have misjudged something and log it up for next time. The 'next time' is all important, for no single drawing can provide all the finding out that has to be done. Stopping one flawed drawing and starting with a brand new sheet of paper will not, in itself, produce miraculously wonderful results. The faults must be fully recognised and then the modified judgements built into a new drawing. No amount of delicate detail will make up for terrible proportions (Fig 36).

CHAPTER 5

The view

There are occasions when our eyes seem to be particularly well in tune with our brain and we suddenly see people with great clarity. A figure seen against a bright window, a friend with a new hat (Figs 37 and 38) – those moments of surprise are rare, but are what some artists strive to arrange with thought and deliberation.

If it is possible, watch your model when in familiar surroundings – notice favourite mannerisms, a pose frequently taken. There is likely to be a temptation to choose the view first seen. Pause for a while and walk right round the model. Consider how the shapes change as you move. The straight on view will not be the most simple, for it will conceal the thickness of the body by which the volume can be described. The side view, though dramatic, presents equal problems for the far side of the face and body will be totally obscured. The three-quarter view, that is one which is half way between a position straight ahead and a side view, is likely to produce the greatest descriptive possibilities. It might even be a view in which the face is not totally seen. The three-quarter view is therefore one which I would strongly recommend.

There is a tendency for those drawing to keep well away from the model. This is fine if the whole figure is to be drawn, for it is essential that the eye should not have to move excessively in order to see the top of the head down to the foot.

FIG 37 This drawing was made at quite a large size (32in/81cm high) which was appropriate for the coarse black and white wax crayons used on a mid-grey paper. Little wax was applied to the actual figure

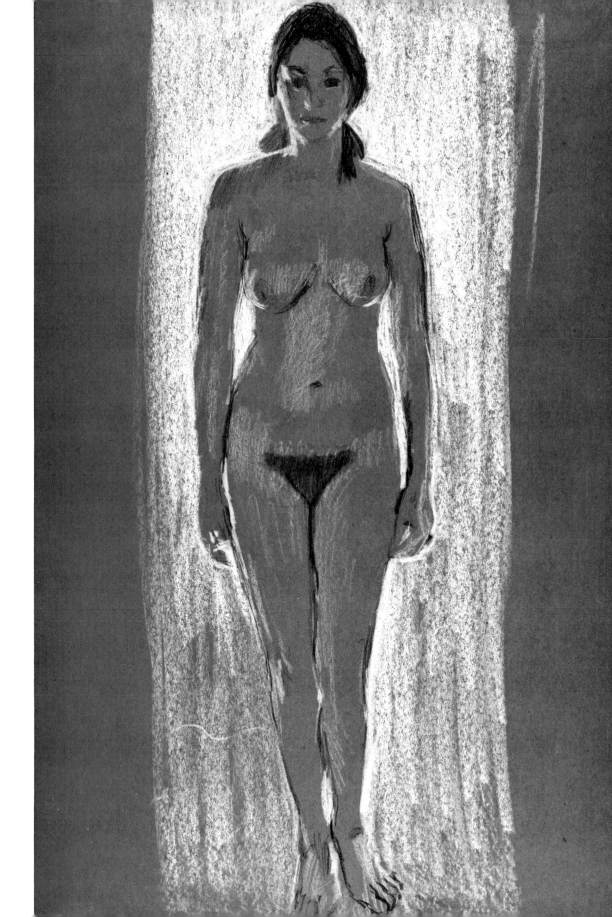

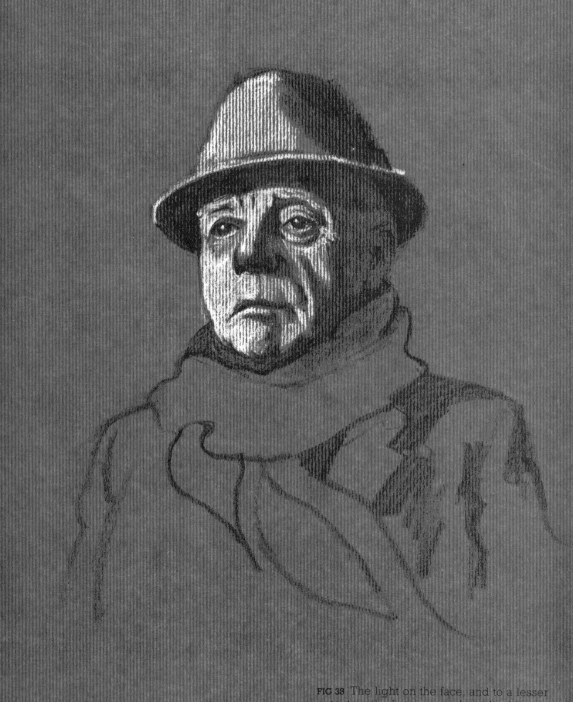

FIG 38 The light on the face, and to a lesser extent on the hat, was made with white wax crayon, while black wax was used for all the darker areas. The drawing was made on brown wrapping paper, used on its matt, finely ribbed side.

42

However, for portrait drawing it is the upper part of the figure which conveys much which we wish to describe. To do this, move as close as possible. A clear understanding of the form of eye-lashes, the corner of the mouth, the shape of the jaw, can do nothing but help the drawing (Figs 39 to 42). This closeness is one of the great advantages of working privately – just artist and model. For all the fun of working in a group with the ability to compare achievement, the crowd invariably means that the view is from far away and the overall figure drawn has to suit those circumstances (Fig 43).

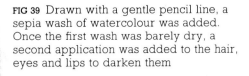

FIG 39 Drawn with a gentle pencil line, a sepia wash of watercolour was added. Once the first wash was barely dry, a second application was added to the hair, eyes and lips to darken them

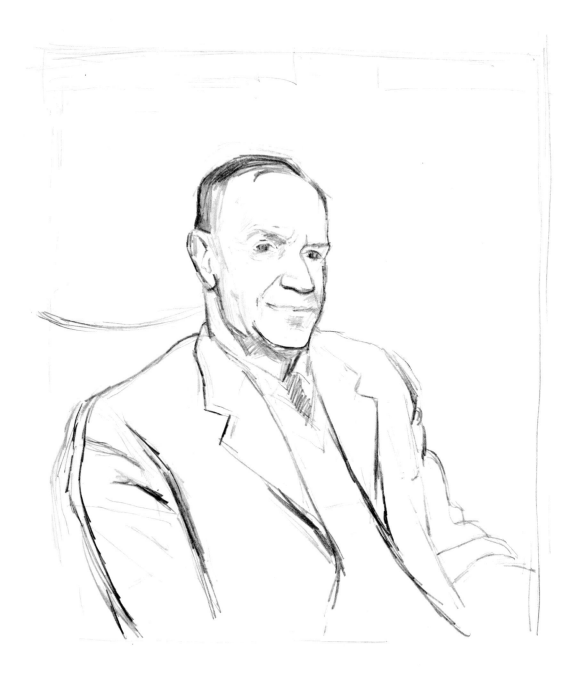

FIG 40 Drawn with a soft pencil this was a
first study for a later oil painting

44

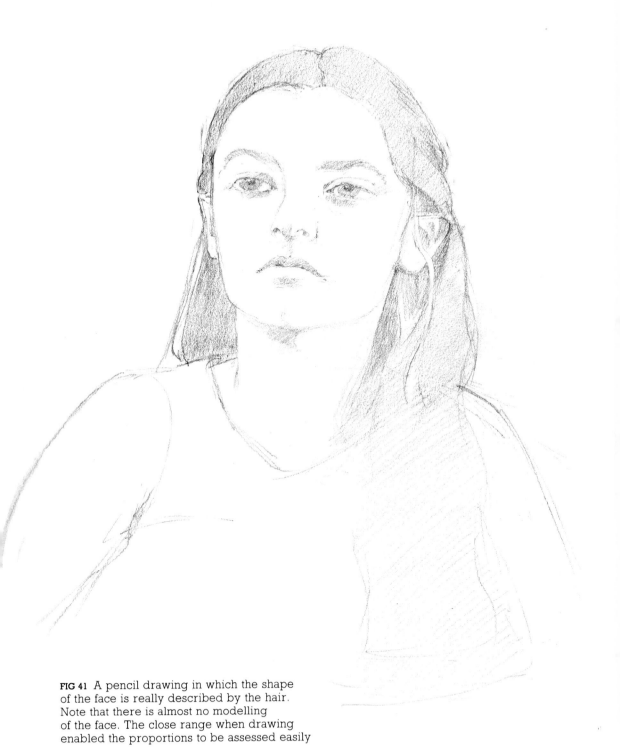

FIG 41 A pencil drawing in which the shape
of the face is really described by the hair.
Note that there is almost no modelling
of the face. The close range when drawing
enabled the proportions to be assessed easily

45

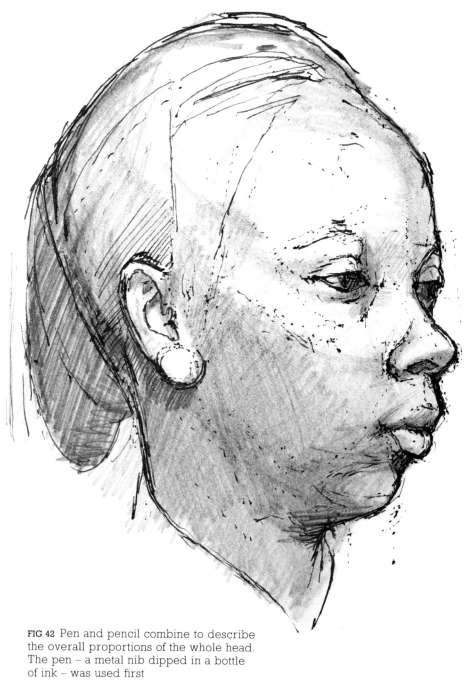

FIG 42 Pen and pencil combine to describe
the overall proportions of the whole head.
The pen – a metal nib dipped in a bottle
of ink – was used first

FIG 43 Drawn in an evening class. Many classes can be crowded and prevent close range work. Here, unable to see the model clearly, I drew a fellow student instead!

47

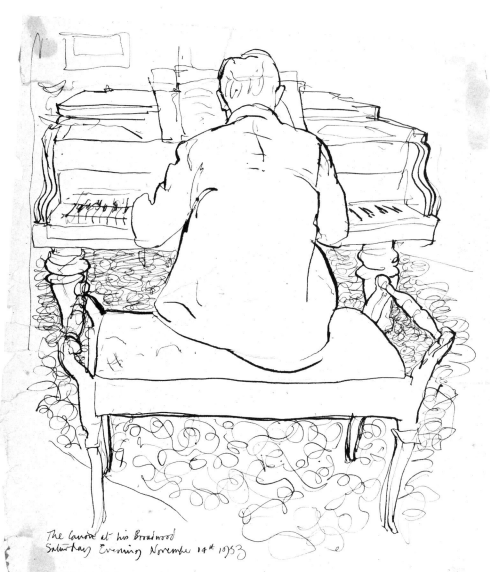

The Canova at his Broadwood
Saturday Evening November 14th 1953

FIG 44 This model was quite content to play the piano. In fact this particular pen drawing made on absorbent newsprint was speedily done in about 20 minutes

In my opinion the artist has to work alone sometimes and indeed has to be quite selfish and able to choose what he or she alone decides to do. This is not always portrayed in fictional characters of artists, who seem always to be depicted in animated conversation and conveniently just stopping work so that the plot can continue; it would be too tedious for the time to pass as the real drawing or painting took place! But the artist, new or experienced, has to concentrate – sometimes for minutes, sometimes for hours – and the model, whose comfort and well-being is paramount to the final success of the drawing, can be no less patient (Fig 44).

48

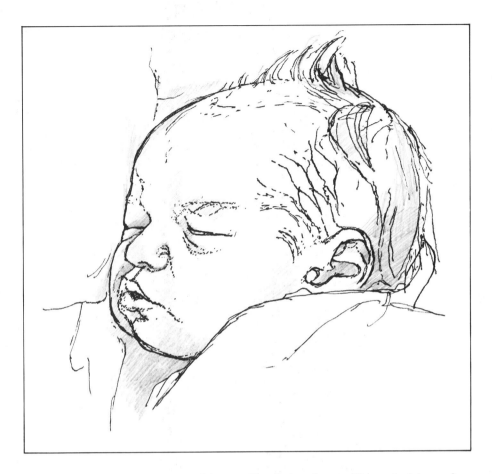

FIG 45 A sleeping baby will not object at all to being drawn. The materials used were pen and pencil

Babies and young children can be drawn when asleep and when awake they will focus on something for short periods: older children often fidget incessantly! Have a drawing book to hand to grasp every opportunity which presents itself, and try very quick drawings. It can be extremely rewarding, although it can equally well be very frustrating if the position changes half-way through. However, do persevere, and if only one drawing in ten is successful it will have been worth the effort. Meanwhile there are lots of older people who will sit with great pleasure and provide you with equal pleasure as you draw calmly (Figs 46 and 47).

Of course the ideal model is one who always starts promptly and is prepared to remain as long as the artist requires. Not as difficult to find as might be supposed – use yourself as a model, and attempt a self-portrait, all you need is a large, conveniently placed mirror! (See Fig 48).

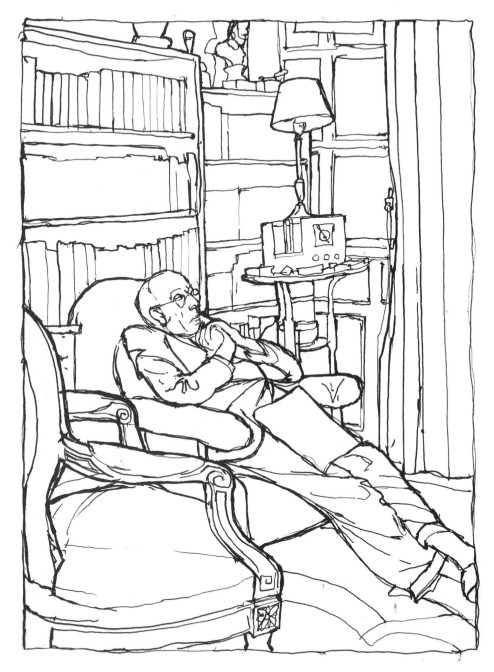

FIG 46 When a young student I was invited to listen to radio concerts. The music provided more than enough to absorb the sitter. The surroundings and pose were entirely natural and drawn with pen and ink

50

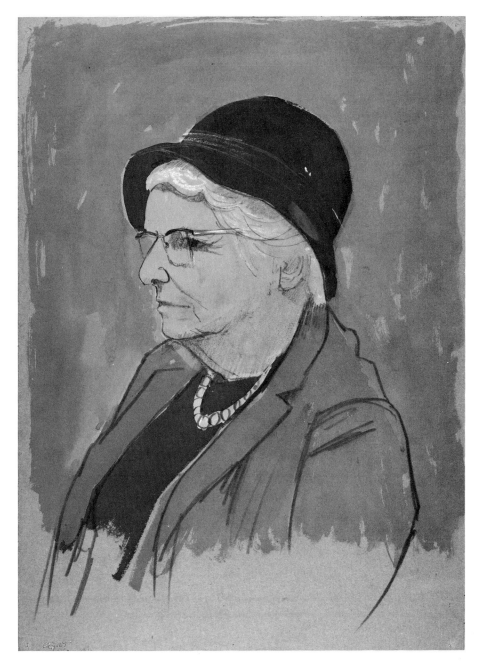

FIG 47 This sitter posed for a class. On a half-tone sheet of sugar paper, poster paint was loosely laid in for the main areas. When dry a soft pencil was used to structure the features and the other boundaries

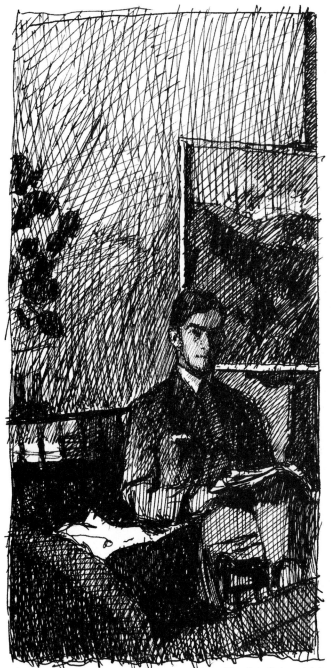

FIG 48 A self-portrait using pen and ink. The book in which I drew is also seen on my knees. The secret is to move only your eyes

CHAPTER 6

Lighting

Imagine a Rembrandt portrait with the model in a pink track suit sitting in a white room, a yellow carpet on the floor and spotlights shining from every direction. A Rembrandt? Surely not. He painted his models in dark rooms with just a glow of light from above, illuminating the face, hands, possibly some light parts of clothing, and little else. Quite so. We can have a person in front of us but the way they are revealed by the particular sort of lighting has an enormous effect upon the drawing or painting which is produced.

There are two main possibilities. The first – daylight. If you are able to complete the drawing within an hour or so, then direct sunlight can be strong and dramatic – resulting in emphatic contrasts of light and shade (Fig 49). But of course the sun moves, or rather the earth does, and quite quickly too, which causes the shadows to change position. This is why many studios have north-facing windows where light – reflected light – can enter, but no direct rays of the sun. In these circumstances contrasts are more gentle (Fig 50). If the figure sits against the light the tones of the body will be low, uniting all surfaces (Fig 51).

However, with varying times of day and changeable weather, conditions are far from constant. This is one of the reasons why artists have many short sittings, providing a quality of light as near the same as possible for each period of work.

One of the stories I heard during my days at the Slade concerned Wilson Steer who was a tutor there. On a gloomy November day he was teaching in the men's life room and it is reported that he looked at the model, looked up at the tall north-facing windows, and turning to his students said, 'Well, gentlemen, the light's gone – thank God!'. For all of us who at one time or another have struggled to improve our drawings, it has indeed been a happy release when circumstances outside our control have brought a halt to our endeavours.

On the other hand when days are less leisurely and particular times cannot always be chosen, lights – particularly spotlights (bulbs with a reflector as part of their construction) – can produce drama and mood. They will also

produce a constancy of light which allows work to continue whatever the condition of the day outside (Fig 52). Some artists do not like artificial light for painting, but where colour is not of concern and only line and tonal values are under consideration, it can be an excellent way to draw.

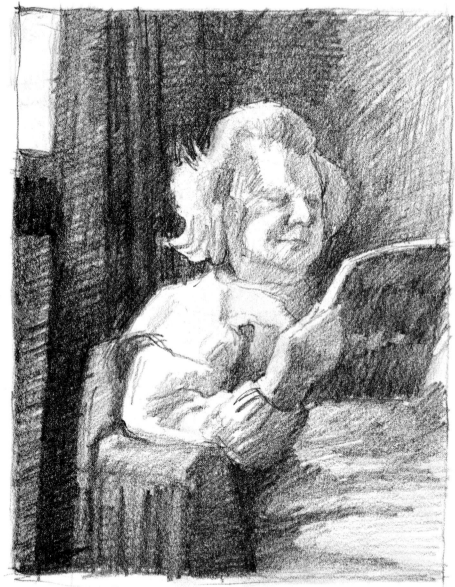

FIG 49 A pencil drawing in which the figure is sitting in strong light coming from a window behind her. The effect is achieved by the maximum contrast with the dark curtains. Notice that the book reflects the light back onto the face

54

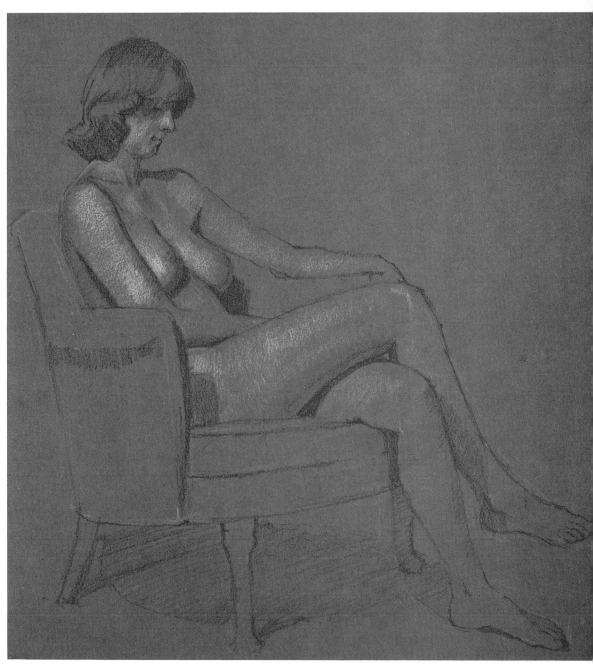

FIG 50 Indirect light produces soft gradations and shadows. Black and white wax crayon on grey paper

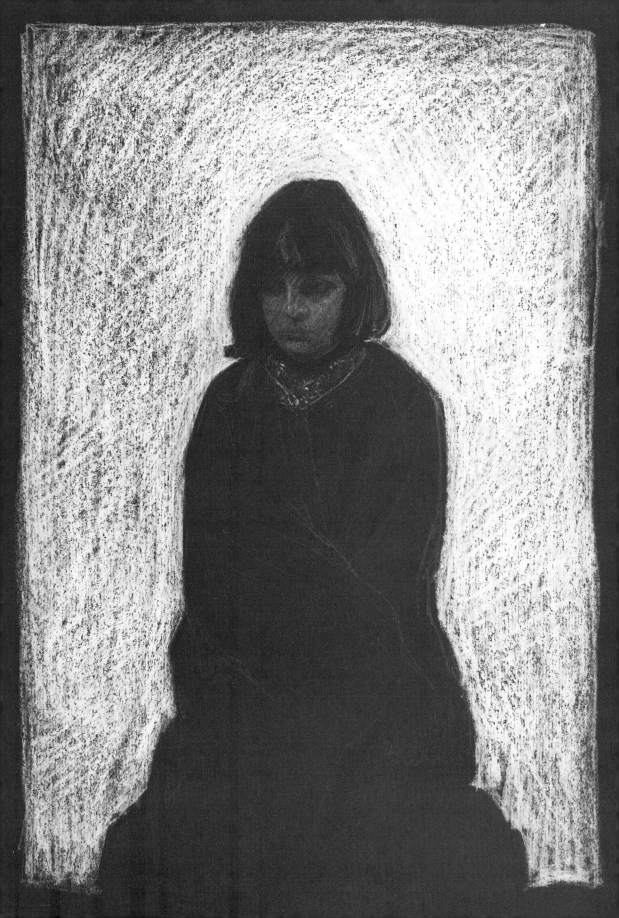

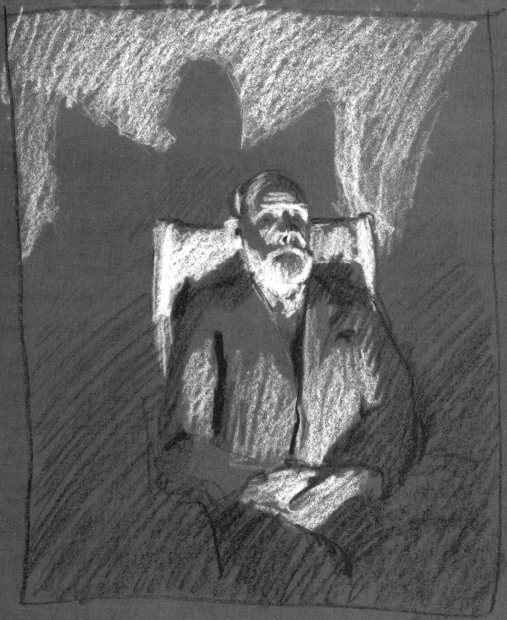

FIG 51 Drawn in white wax crayon on black paper. The wall behind the sitter was
illuminated, leaving the figure an overall dark tone

FIG 52 Black and white wax crayon on a half-tone paper, with a spotlight shining
upwards from the floor. Notice the shadow on the wall behind the sitter

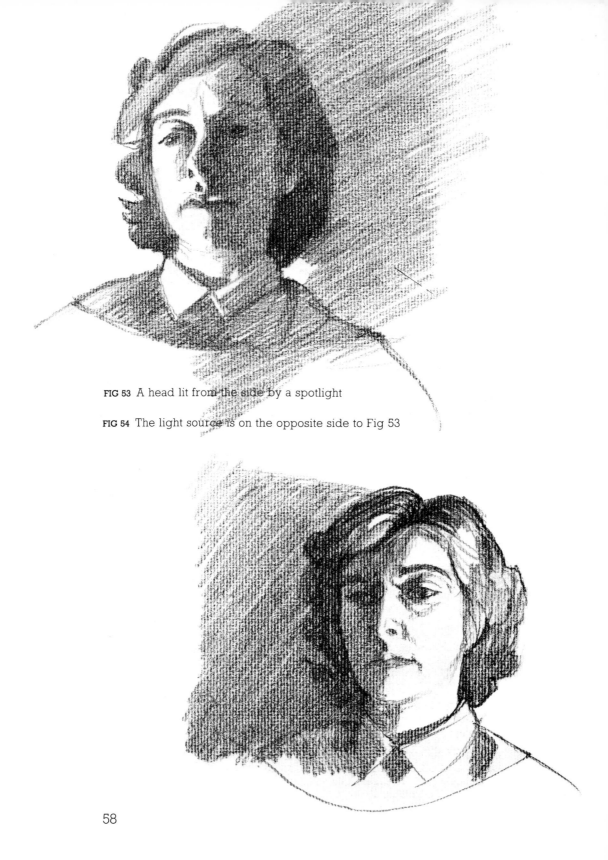

FIG 53 A head lit from the side by a spotlight

FIG 54 The light source is on the opposite side to Fig 53

58

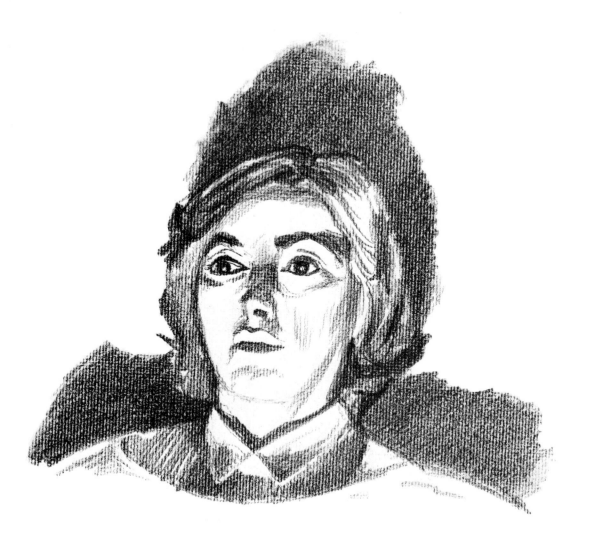

FIG 55 The head as seen in Figs 53 and 54 but lit from below. Notice how the change in lighting reveals different shapes in the same head which in turn will lead the artist to emphasise different characteristics

The movable standing spotlight is ideal because one can direct the light from top, side, or even from below. A model lit in different ways shows how the same form can be altered in appearance (Figs 53 to 55). When shading the darker areas of the model, ensure that you do not over-value the highlights which you may observe within the shadow area. Sunlight or spotlights will invariably dominate the form, and any dark coloured areas, hair or clothes, are likely to be quite pale in the light, whilst pale areas will, in the shadow, become darker than you might first suppose – in fact become a part of the shadow. When skin has changed colour and tone because of the sun it may be necessary to soften any sudden changes. A nude with bikini patches can be quite a problem!

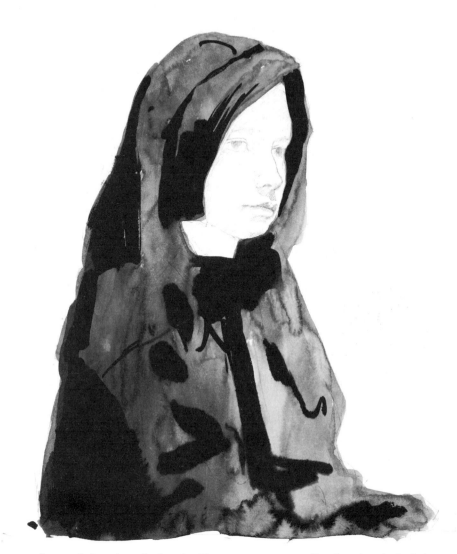

FIG 56 A pencil drawing of a head with a strong surrounding hood and cloak in watered down ink, and full strength black applied with a large brush

Clothes, of course, will add most of the violently different tones and many have particularly strong characteristics which are a task in themselves to interpret (Fig 56). Stiff collars and lapels, padded shoulders, thick, firm material contrasting with light fluffy wool, or the thinnest of silk. Between these are never-ending areas of denim! One of the most dismal garments I have ever drawn is a pair of jeans; they neither have any striking form of their

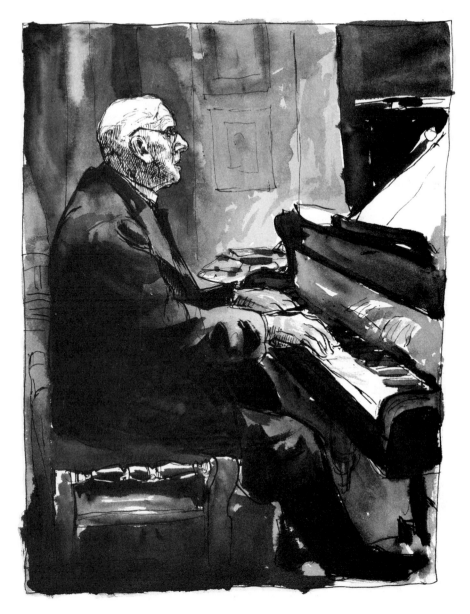

FIG 57 A pen and ink drawing with additional washes of full strength and diluted drawing ink. The remaining areas of untouched white paper are vital in portraying the lighting from above. Notice how the dark clothes do not reflect as much light as the white hair, paper and keyboard

own, nor allow the subtle shape of the leg to be seen. But that of course is a personal feeling. Seams and patterns can follow form, or encircle it; or sometimes act as a camouflage and require treatment as a flat pattern. Belts, cuffs, jewellery and even watches can add elements which describe the figure by encircling parts of the body (Figs 57 to 60).

61

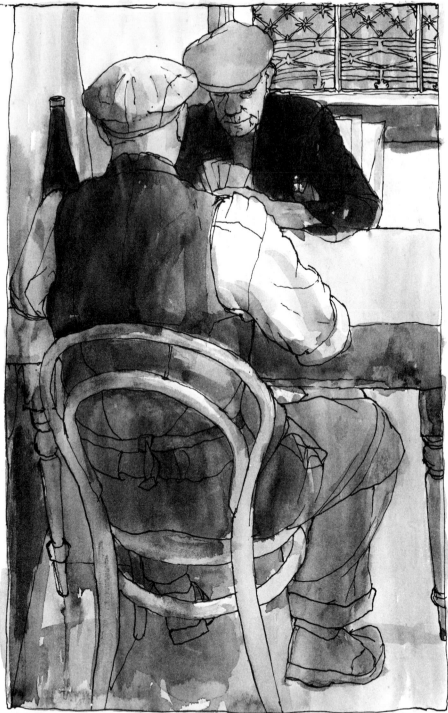

FIG 58 These two men playing cards were in fact an effective class pose. The caps and waistcoats, and the bentwood chairs, add most of the 'character'. Pen and wash

FIG 59 A pen and ink drawing where the tone has been built up with lines and cross-hatching

63

FIG 60 Pen and pencil. A model wearing an evening dress with a large collar. By encircling them, this does much to describe the depth of the shoulders

My suggestion is to allow your model to wear what is natural, and appropriate to the overall character being portrayed. Informality or formal uniform – only the artist and model can agree on what seems right to both (Figs 61 to 64). Dressing up a model in different clothes provides much variety. Some of my most loyal models have been quite game to become another character – but not everyone is happy to do so.

FIG 61 A loyal model of many drawings. Seen here in a favourite jacket, he always sat with such relaxed sympathy to those drawing that every pose seemed to be vital and new. Black wax and watercolour wash

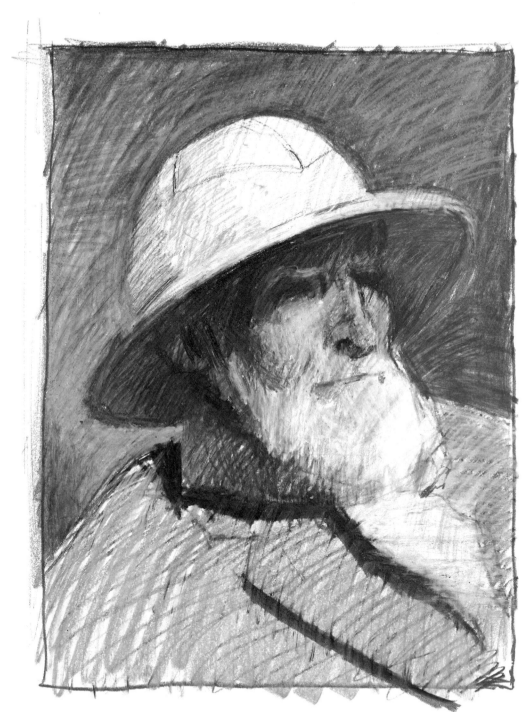

FIG 62 The same model as in Fig 61, but this time wearing a pith helmet. Wax crayons

66

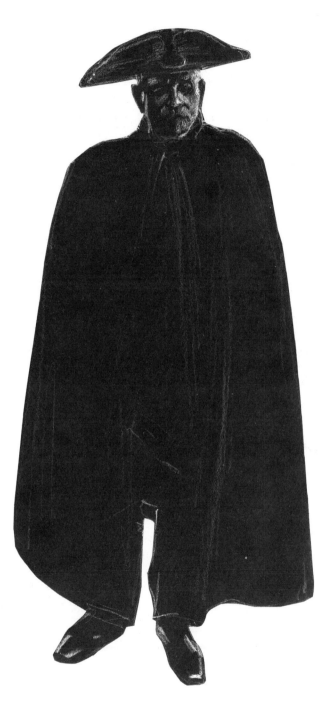

FIG 63 A cloak and tricorn hat transform a model. A drawing in white pencil on black paper was cut out with scissors and mounted on a white background

67

FIG 64 The same model as in Fig 63, but this time dressed in a mitre and cloak. The cloak is an excellent garment enabling normal clothes to be effectively covered without the nuisance of fitting or changing clothes

68

Michael Woody 15·2·77

FIG 65 The model previously seen in Figs 63 and 64 but this time wearing his own outdoor clothes. Set against a light background this picture provides an example of drawing in low tones using chalk and charcoal

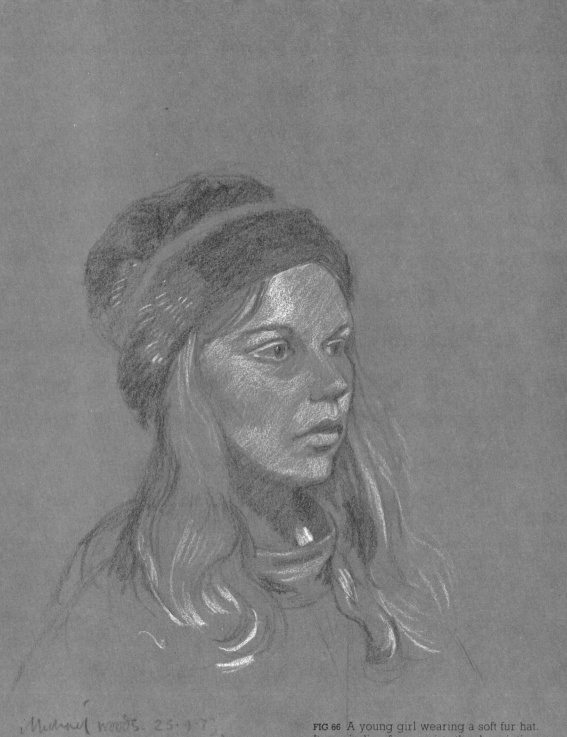

Michael Woods. 25·9·73

FIG 66 A young girl wearing a soft fur hat.
Its encircling form assists the description
of the volume of the head. Black and
white wax pencils on half-tone sugar
paper

FIG 67 Long, smooth, dark hair drawn with
a soft pencil. Owing to its shiny nature, the
actual tone in the areas reflecting the
most light is quite pale

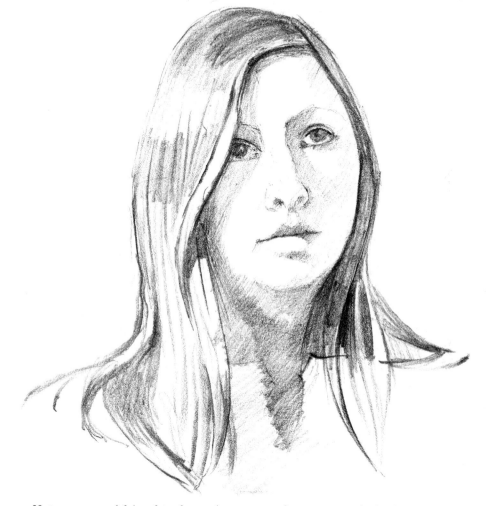

Hats are a real friend to the artist, strong shapes to encircle the head and
frequently contrast in colour and tone. In fact coats and scarves, anything
associated with outdoors, can give considerable interest (Figs 65 and 66).

But under the hat, what of hair? Smooth hair cut to a crisp shape can be a
delight to draw, as its form is clear and can be shaded like any other. If the hair
is of a dark colour do not over-darken the light side, because although the
verbal description might be 'black hair', in the light it will shine and have
considerable variations paler than you might think (Fig 67).

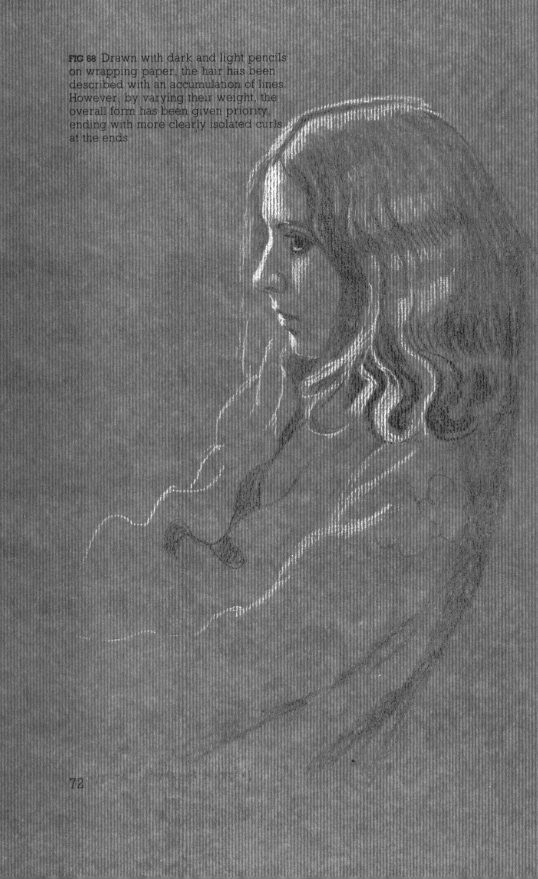

FIG 68 Drawn with dark and light pencils on wrapping paper, the hair has been described with an accumulation of lines. However, by varying their weight, the overall form has been given priority, ending with more clearly isolated curls at the ends

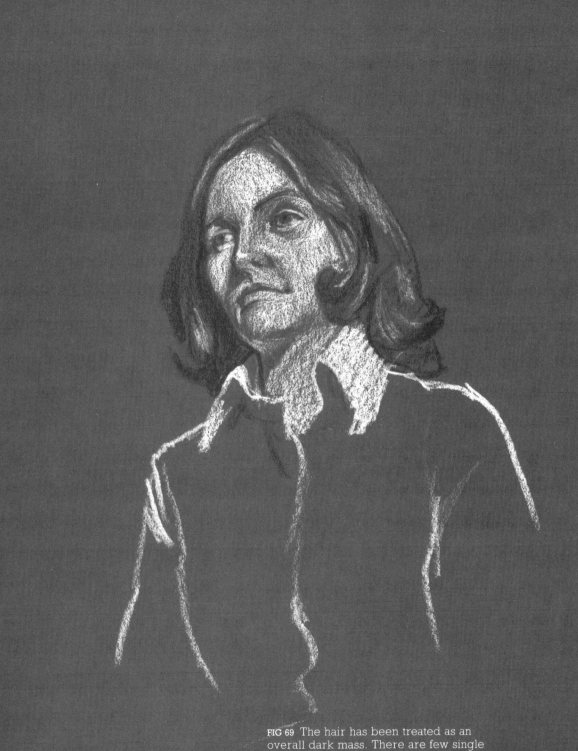

FIG 69 The hair has been treated as an overall dark mass. There are few single lines, while the characteristic curls are given emphasis

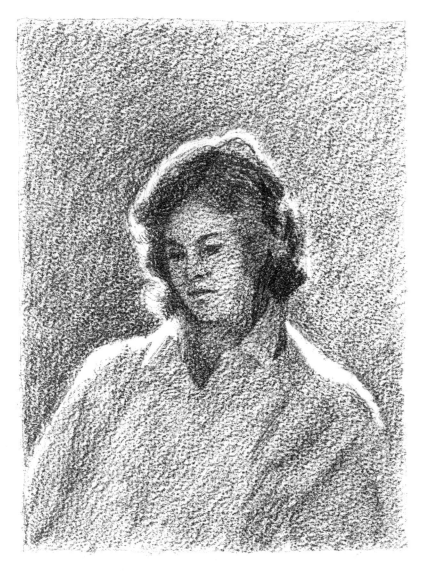

FIG 70 A girl with the source of light behind her back creating a halo round the edge of the figure

Hair is understood to be a dense collection of strands, and the temptation to draw many lines to represent many hairs is common. But the result of this method of description is not always convincing. Hairs are most frequently gathered in groups or clusters or curls, and it is much more important to draw the shapes of these (Figs 68 and 69).

When hair is particularly fine, the boundaries will be soft and very fuzzy. If lit from behind then the edge may glow with a halo effect (Fig 70).

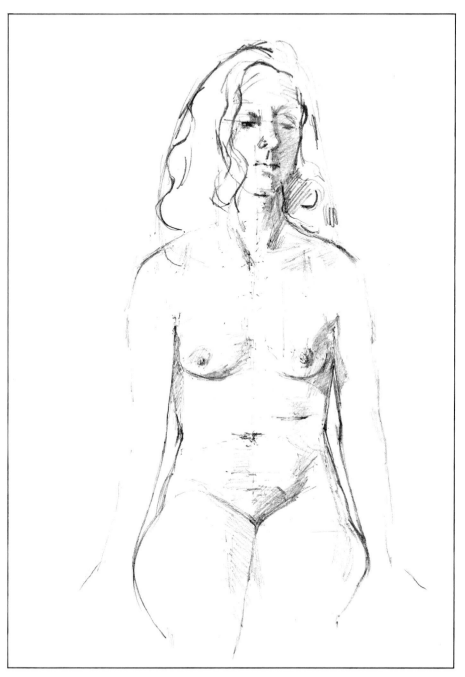

FIG 71 The hair of this model has not been given more attention than any other part. This maintains the overall unity rather than creating division within the figure

The treatment of hair in a pencil drawing may well be to softly shade all over, diagonally, darkening the area away from the light and adding a few darker lines where these become noticeable in the model. Alternatively, complete a first pale shading, which will represent the main tufts of hair, then darken the gaps between these pale patches. Above all, do make certain that the change between hair and skin, particularly where the hair is seen at its roots, is gentle and without a harsh boundary. If it is made over-harsh, then an artificial, wig effect will be the result.

When drawing a nude, the variations between skin and hair can be obvious. I suggest that the contrast be played down for the sake of overall unity in the figure. Remember the hair only clads the form and in most cases does not totally obliterate it (Fig 71).

Long hair can be very dramatic but when seen from the rear the line between back and hair can be an uncomfortable one. In addition it masks the neck and conceals the back of the skull. Although at first it may seem easier to draw the model like this, in fact you will find it simpler if you can see the shape of the neck and shoulders, so if the hair is gathered up in a ribbon it will be much to the draughtsman's advantage.

CHAPTER 7

Anatomy

Arms and legs are well understood by most people: children give them prominence by showing them as sticks added on to a round blob! The body is a rather unknown lump and not surprisingly the less experienced draughtsman can 'lose' quite a bit of it!

When drawing a figure it is quite easy to think of the flat outline of the shape, but anatomy is about volume (Fig 72) and the spine is at the back of a bumpy-shaped sort of cylinder. The spine is a collection of linked bones which can bend about; hanging on to the front of this is a rib cage (Fig 73) – the word 'cage' is a good description for although it can contract and expand a bit, it is on the whole a rigid unit. At the bottom of the spine is the pelvis – a sort of bone saucer which holds the abdomen (Fig 74). This does not move in itself but, being connected to the spine, can tilt (Fig 75). This tilting is transmitted to the legs, and vice versa, by the femur (Fig 76) – a rigid bone but freely jointed at the pelvis. The lower leg created by two bones cannot bend but it can have a limited twist (Fig 77). The two leg parts of course can bend at the knee, which can also be clearly seen in Figure 75.

The arm is similar to the leg with two bones jointed to the single humerus (Fig 78), but instead of a fixed pivot to the body it is linked by a sliding plate, the scapula (Fig 79) – the movement is limited but greatly adds to the flexibility of the arm (Fig 80). Throw out your chest and push both your arms back trying to force your shoulders together. You will feel the degree of movement of your scapula.

Throughout the whole figure one will find many near straight lines (Fig 81), and the hand is a good example (Fig 82). Not a bunch of bananas, but rather a set of planes each set at a slightly different angle. The division into fingers merely divides these planes. When a figure or part of it looks complex it will be helpful to think of the general directions of these planes which underlie all the forms. They give a sort of scaffolding round which one can add or subtract the actual shapes.

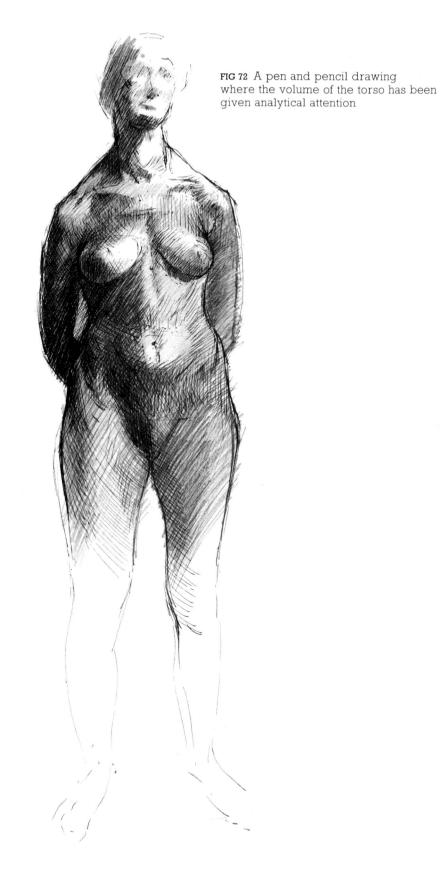

FIG 72 A pen and pencil drawing where the volume of the torso has been given analytical attention

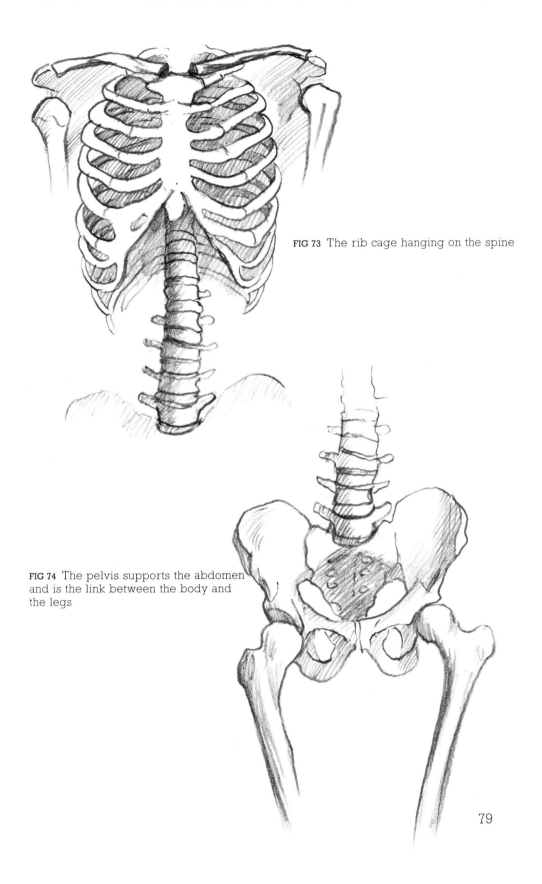

FIG 73 The rib cage hanging on the spine

FIG 74 The pelvis supports the abdomen and is the link between the body and the legs

79

FIG 75 Two figures, both sitting but in a different manner. Notice how the pelvis can twist and the legs bend to extreme angles

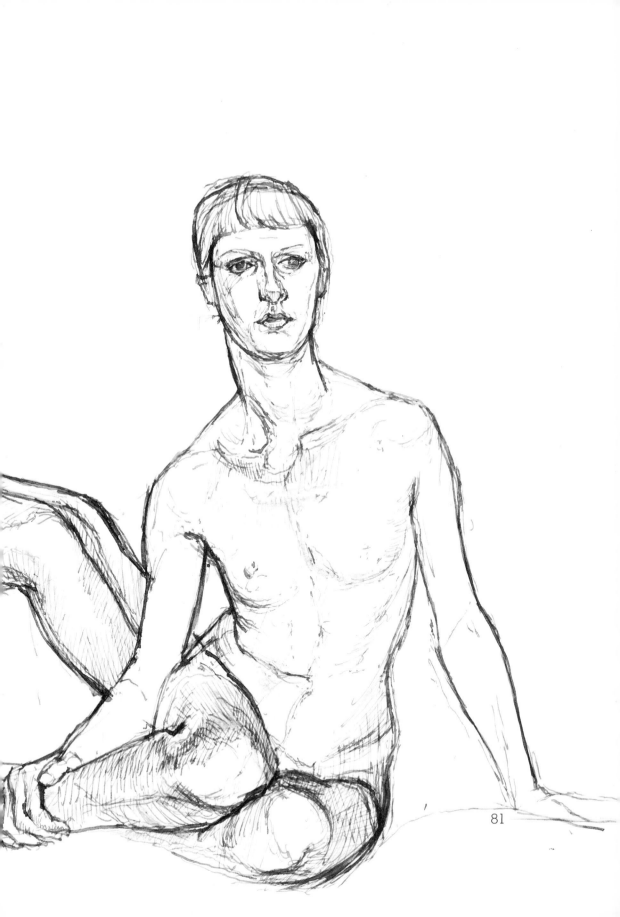

81

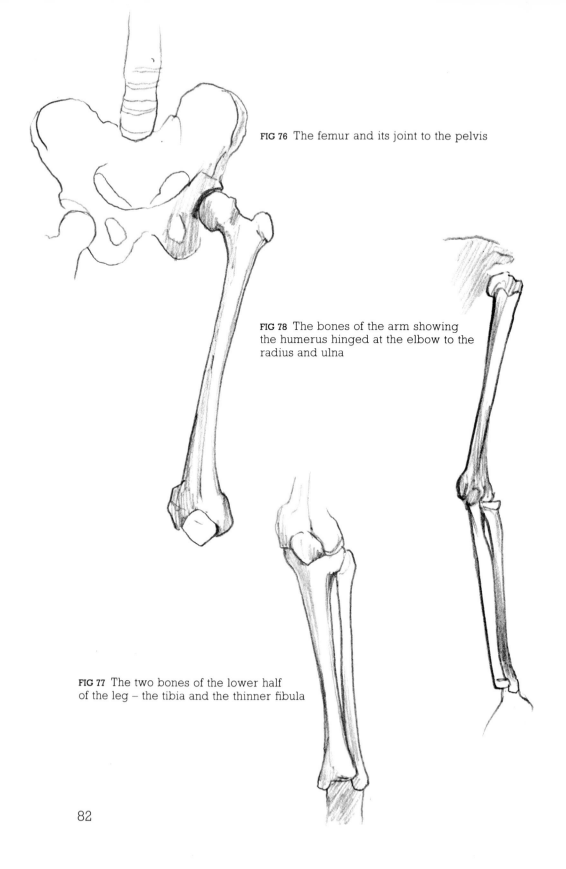

FIG 76 The femur and its joint to the pelvis

FIG 78 The bones of the arm showing the humerus hinged at the elbow to the radius and ulna

FIG 77 The two bones of the lower half of the leg – the tibia and the thinner fibula

82

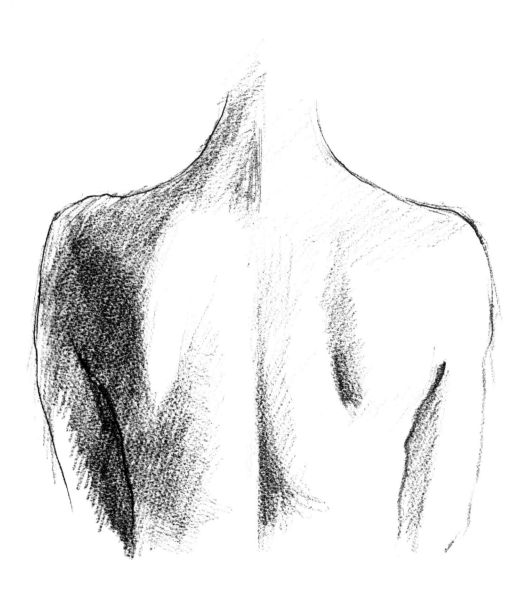

FIG 79 The plate of bone, the scapula, by which the arm is able to slide across the back of the rib cage

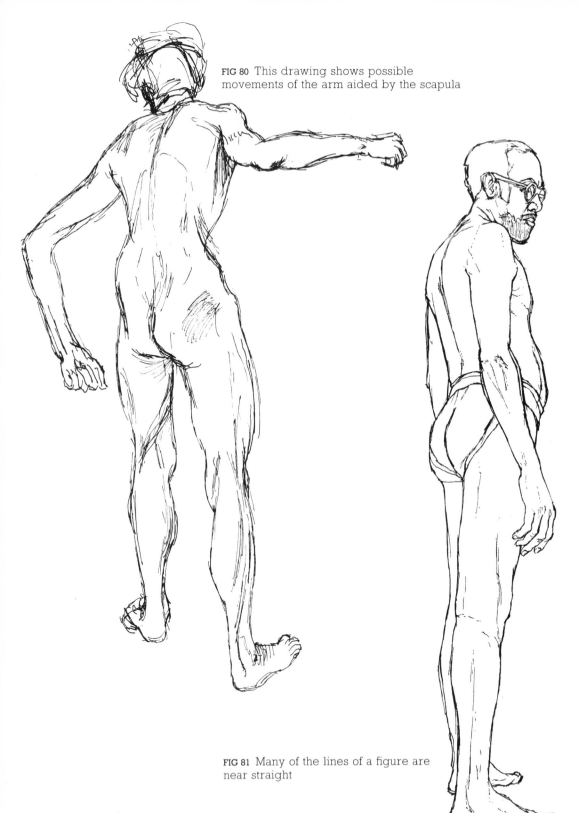

FIG 80 This drawing shows possible movements of the arm aided by the scapula

FIG 81 Many of the lines of a figure are near straight

84

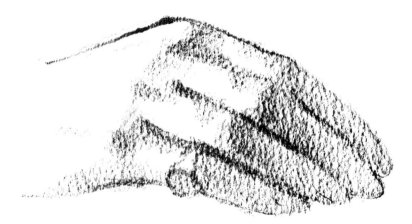

FIG 82 The edges of the fingers are less important than the planes created by the bending of the knuckles

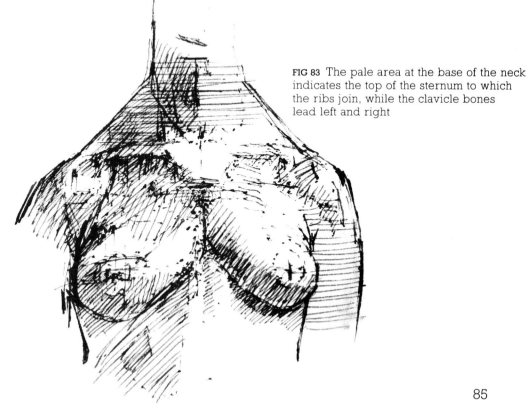

FIG 83 The pale area at the base of the neck indicates the top of the sternum to which the ribs join, while the clavicle bones lead left and right

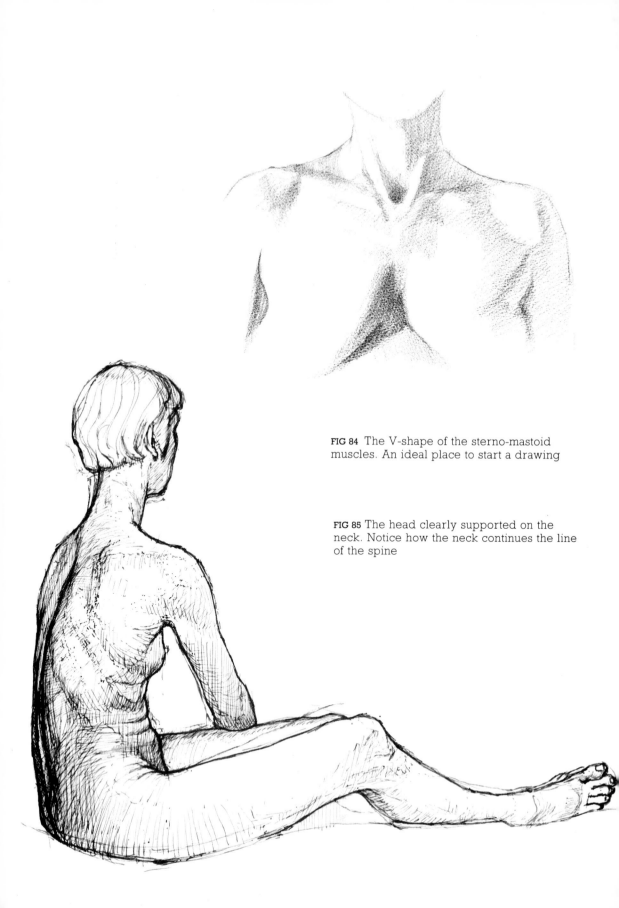

FIG 84 The V-shape of the sterno-mastoid muscles. An ideal place to start a drawing

FIG 85 The head clearly supported on the neck. Notice how the neck continues the line of the spine

Returning to the front, the ribs have a central meeting point on the sternum (Fig 83). The manubrium at the top is one of the valuable visual points for the artist, for there is little covering on this mid-point and from it, either side, the clavicle bones run out to the shoulders, while upwards the two sterno-mastoid muscles run up the neck (Fig 84) and bring us to the head (Fig 85). This is supported by the spine and once again, though it can turn and tilt in itself, it is a fixed unit save for the upward and downward movement of the jaw.

There are some muscles which are more obvious and therefore more helpful to the artist – though I must say in the female body it can be exceedingly hard sometimes to make out any clearly defined boundaries of muscles, for they seem to melt into one (Fig 86). The diagrams (Figs 87 and 88) show these, but in general terms the most valuable factor which they create is a sort of weaving in the forms and boundaries (Fig 89). Boundaries will not describe just one cylindrical shape, but more than one, twisting and turning through another.

FIG 86 Bones and muscles can be very hard to identify individually. Some understanding of them however will help to maintain sound drawing

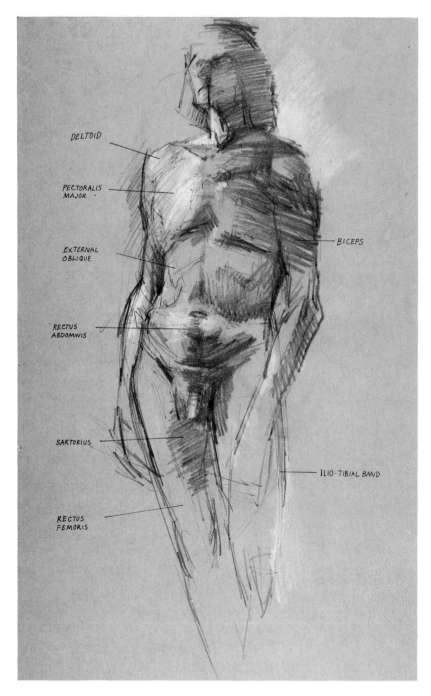

DELTOID

PECTORALIS
MAJOR

EXTERNAL
OBLIQUE

RECTUS
ABDOMINIS

SARTORIUS

RECTUS
FEMORIS

BICEPS

ILIO-TIBIAL BAND

FIG 87 Muscles of the front

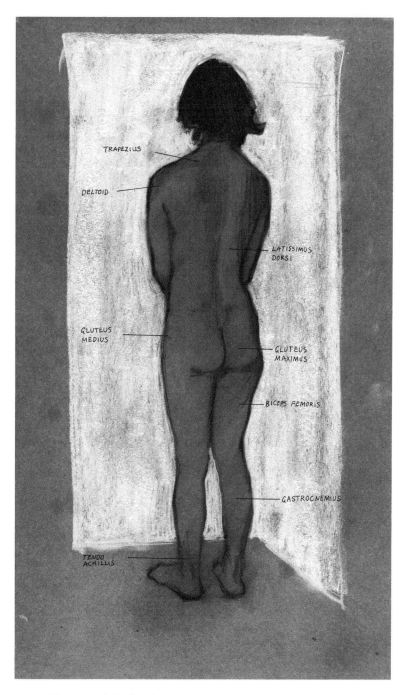

TRAPEZIUS

DELTOID

LATISSIMUS
DORSI

GLUTEUS
MEDIUS

GLUTEUS
MAXIMUS

BICEPS FEMORIS

GASTROCNEMIUS

TENDO
ACHILLIS

FIG 88 Muscles of the back

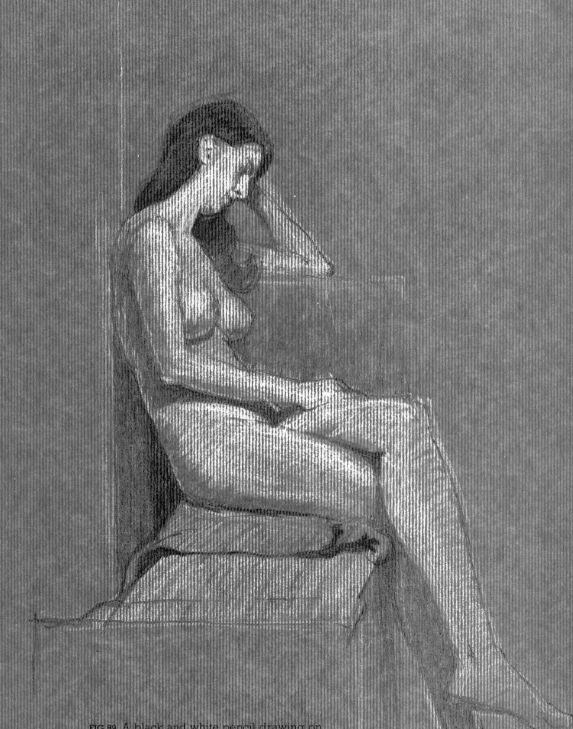

FIG 89 A black and white pencil drawing on wrapping paper showing the 'weaving' of limbs

90

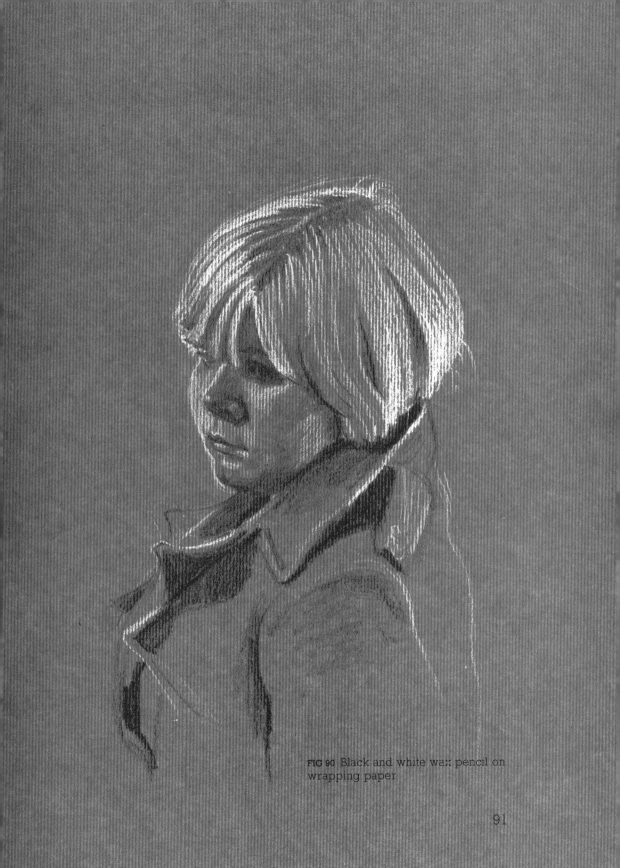

FIG 90 Black and white wax pencil on wrapping paper

91

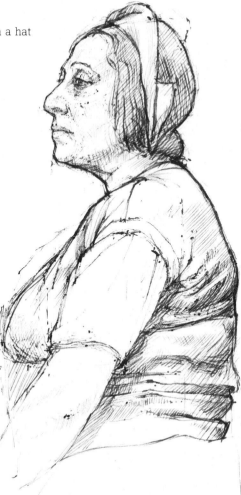

FIG 91 Pen drawing of a lady with a hat

Of course the subject is huge and I am very conscious that I am only just touching on it. Knowledge of anatomy does not in itself make a good drawing, indeed it might even produce a very stilted result. However it is similar to perspective in that it alerts the eye and can help understanding, thus allowing a drawing to be made with greater freedom and spontaneity. However, it is to the head that we look for immediate identification, searching for character and feeling. So much can be conveyed by so little change. Infinitely small contractions or changes in proportion can convey such subtle variation (Figs 90 to 93).

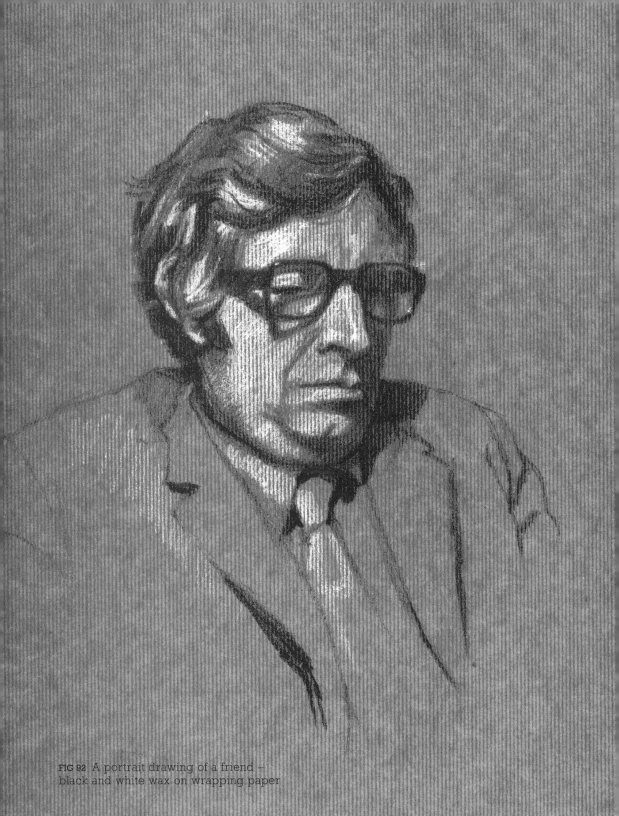

FIG 92 A portrait drawing of a friend –
black and white wax on wrapping paper

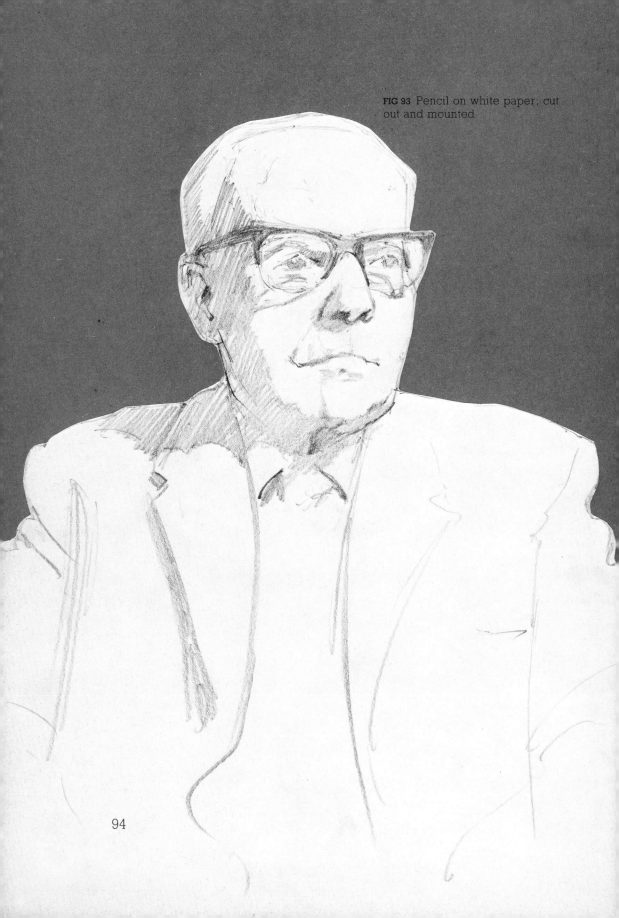

FIG 93 Pencil on white paper, cut out and mounted

94

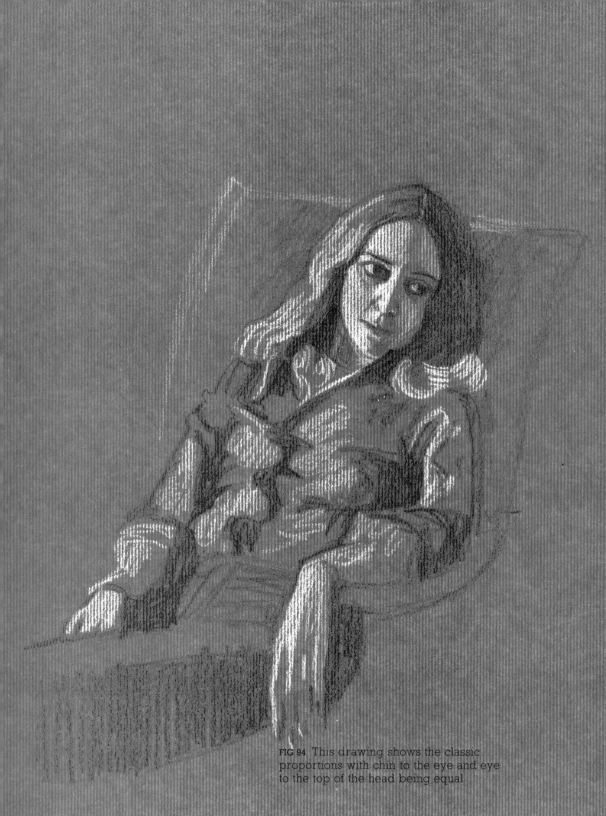

FIG 94 This drawing shows the classic proportions with chin to the eye and eye to the top of the head being equal

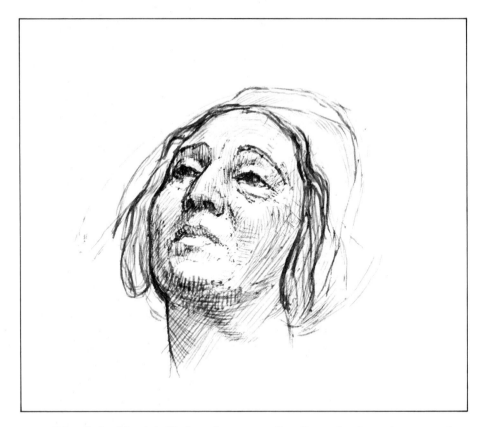

FIG 95 A head tilted back is likely to have a smaller dimension from the eye to the top of the head compared with eye to chin

There may be a temptation to give all your attention to the nameable features, eyes, nose, lips, but it is the spaces between these which either mar or make the whole head fit together.

Using your stretched out arm, and holding a pencil as a measuring stick, compare the distance from chin to eye centre, and from eye to the top of the head. Invariably they will be equal (Fig 94). Very often, if there is a fault, the top of the head will have been drawn too small. The tilt of the head and your view of it will of course affect the proportions, but do give this measurement your full consideration (Fig 95). The eye sits in the socket – a hole in the bone, the tired eye shadow marks the lower boundary of the socket – feel it for yourself with your finger (Fig 96). If the model wears glasses their clear shape will help in dividing areas and may prevent the nose from being made too long (Fig 97). There will be only about a finger-width between the bottom of the eye socket and the top of the nostril. If the mouth is placed too far below the nose, it will look as if it is drifting away. Think of the space very carefully.

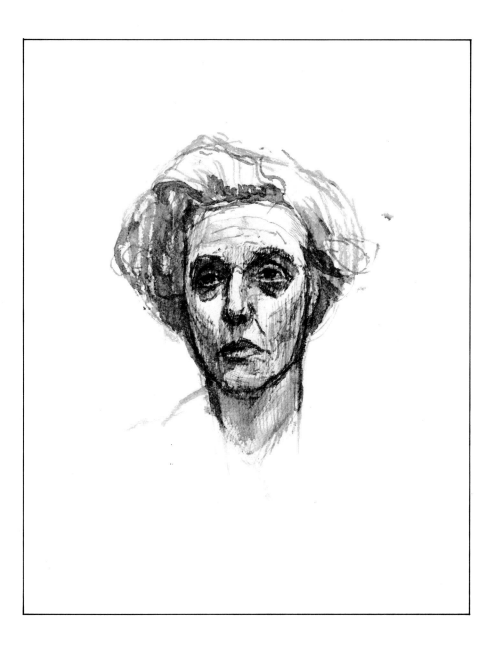

FIG 96 A model with a strongly defined eye socket. Pen and ink

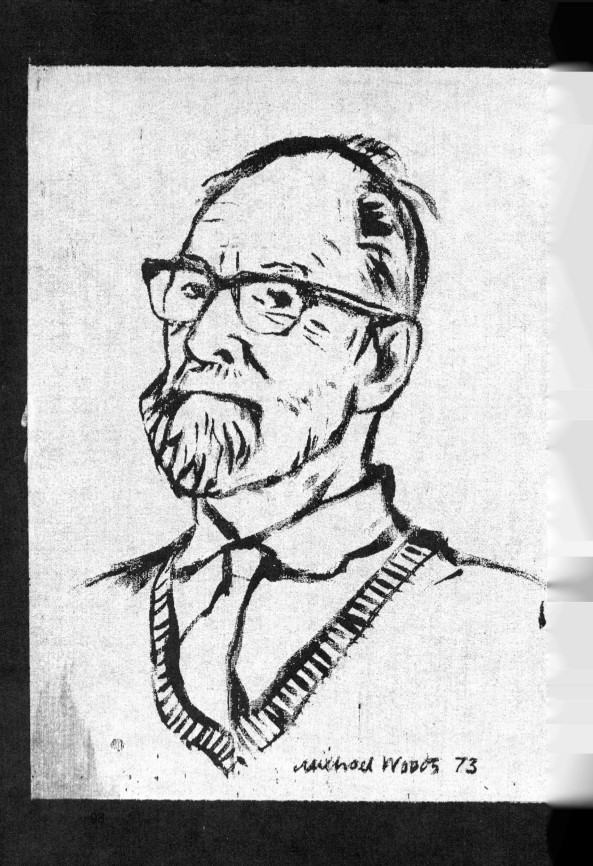

michael Woods 73

FIG 97 Glasses can help one judge the length of the nose. Drawn with shelac directly on to a silk screen and then printed with white ink on black paper

FIG 98 Lips may be best described with the minimum use of a boundary line; shading is most descriptive. Pencil

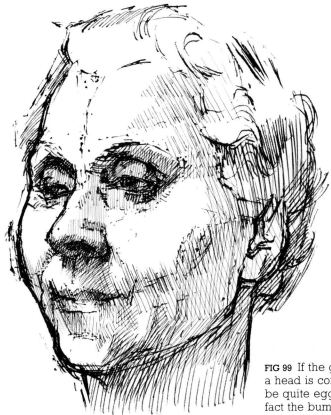

FIG 99 If the generalised shape of a head is considered it may well be quite egg-shaped but in actual fact the bumps and hollows are more important than that theoretical notion

Lips should not have a hard line edge. Try shading only – with the very minimum of a boundry line for a guide (Fig 98). The top lip – the half in shadow and the shadow of the opening itself will be dark. The bottom lip divides into three with one-third shaded on the shadow side. The other two-thirds will be shown up by the shadow beneath the bottom lip, the slight hollow before the chin. These shadows will need very soft edges, even the line of the chin will have a softer edge than the contrasts between jaw and neck might lead one to believe.

Please don't draw the head as an egg. Once that overall suggestion has been made, that's as far as it can help (Fig 99). By all means keep the conception in your mind as one appreciates the planes, but try drawing actual surfaces and boundaries, and actual proportions. Using a theoretical shape for a figure can be as harmful as the advantage it is supposed to bring. Just draw, think and draw again.

100

CHAPTER 8

Materials

A sketch book is only one of a number of alternatives which provide a choice to suit changing situations. The little hard-backed pocket book can be always to hand for those unpredictable opportunities which require immediate reaction (Fig 100). With a pen or a 2B or 3B pencil, preferably having had some sort of protection from a metal top (an old silver one can be ideal), one can immediately go into action (Fig 101).

Larger books need a stiff-back board or they will be floppy and yield to pressure. Heavier, but rigid, a drawing board will have paper pinned or clipped to it. It is always worthwhile having several sheets on a board – a quick change to a new sheet can be made, and any blemishes in the board's surface lost by the extra padding provided. Beware though, when working outside. Changing loose sheets, even in the slightest breeze, can be quite hazardous. A shoulder bag is an ideal home for most materials (Fig 102).

Throughout this book the drawings are made with a variety of drawing instruments: pencil, chalk, charcoal, pen, brush. All are possible, no one better than another – but variety of use will give greater experience (Fig 103).

The pen is one of my favourite instruments, but it must flow easily and if it contains its own ink supply it must not leak. Never lend it to anyone, because the nib will not like the change in pressure from a different hand.

Soft drawing materials like conté sticks, chalks and charcoal are probably less suitable for figure work unless working at a larger scale (Fig 104). Larger drawings can have great power, but will need the use of a drawing board and probably an easel. A light sketching easel (Figs 105 and 106) may not be suitable on a slippery floor surface, but a heavier tri-point can be ideal, though ease of transport may come into question. The full size H-base easel is often the pride of an artist with a studio, but this means that the model will have to come to you.

The proverb about the poor craftsman blaming his tools is probably right, but if tools are wrong or inappropriate they can make for unnecessary difficulties. Experiment with and get to know the materials you use, but for a special drawing never select those which you have not previously tried (Fig 107).

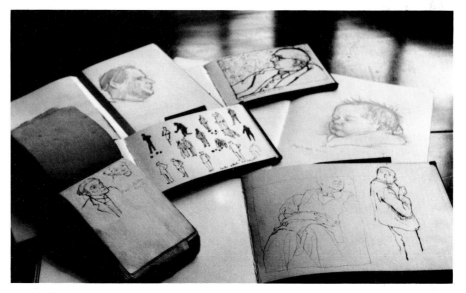

FIG 100 Studies in sketch books

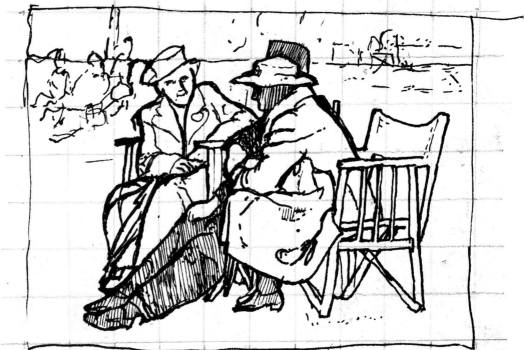

FIG 101 A page from a sketch book showing a group of three people sitting in a park. The squaring-off pencil lines were added later when enlarging the composition. Pen and ink

102

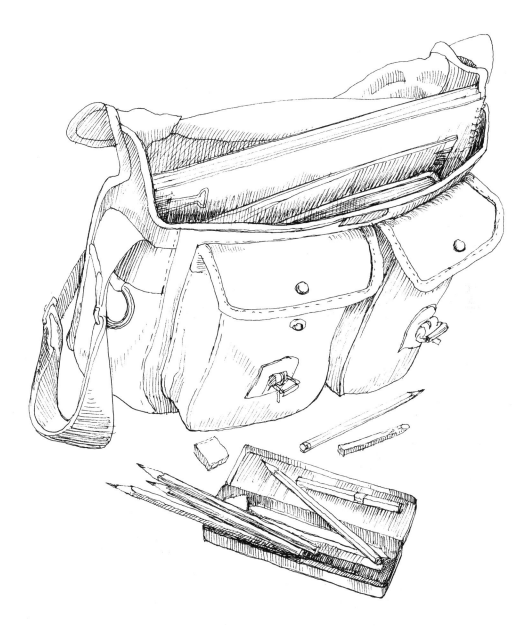

FIG 102 A bag – which might have been designed for other outdoor pursuits – can
be ideal for the artist's materials

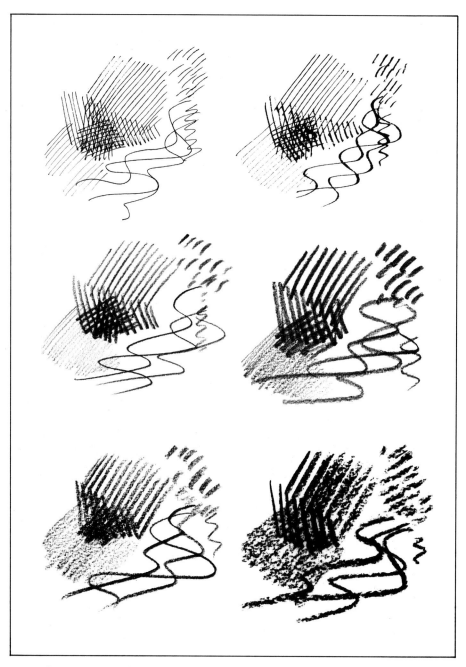

FIG 103 Sample of: pen/thin nib (*top left*); pen/ broad nib (*top right*); pencil/soft 2B (*middle left*); pencil/very soft 6B (*middle right*); charcoal pencil (*bottom left*); charcoal stick (*bottom right*).

104

FIG 104 A drawing using charcoal and chalk on grey paper for which the rather larger size (16in × 23in[41cm × 59cm]) is suitable

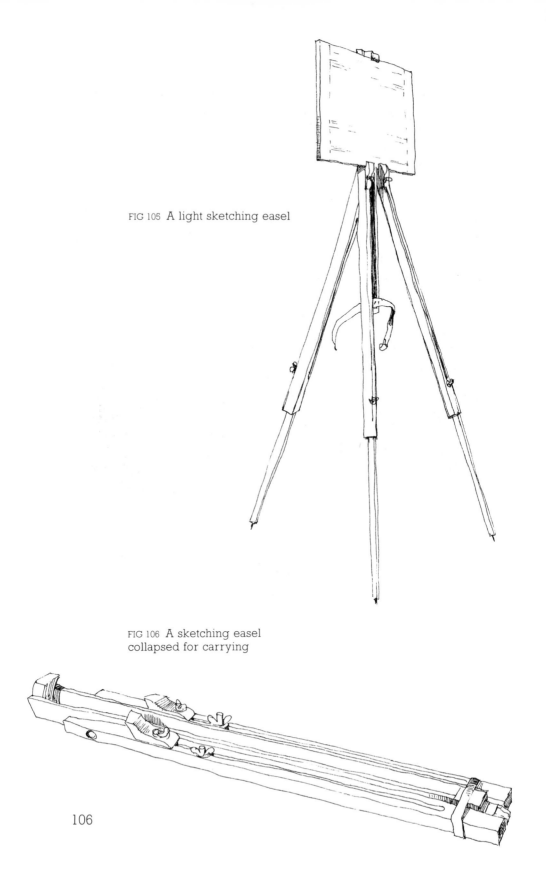

FIG 105 A light sketching easel

FIG 106 A sketching easel
collapsed for carrying

106

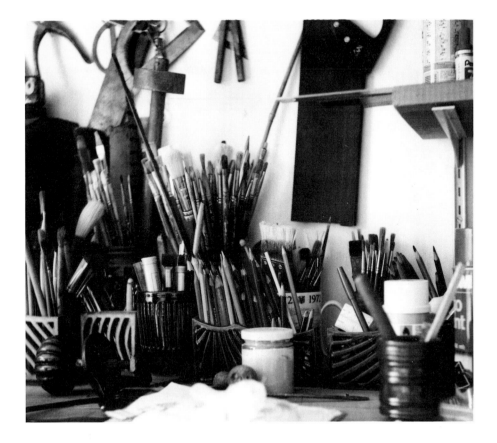

FIG 107 An accumulation of pencils, pens and brushes, gathered over the years

CHAPTER 9

Additional suggestions

To see your own drawing as if you had never seen it before creates a condition of surprise which in turn will alert you to errors of judgement. This can be achieved with the use of a hand mirror. By looking at your drawing through the mirror, the image will be seen in reverse and its characteristics will be immediately more noticeable.

While your model is still present, view your drawing (propped up or on an easel) and the model at the same time, looking through the mirror. You will then be able to consider both model and drawing and make very useful comparisons.

A plumb line, a string with a weight (Fig 108), can calm the mind, clarifying what a vertical really is. This sort of absolute check has its value in the fact that it is just that, a check, to make a contrast to the observation of arms and legs (Fig 109). A length of thin dowel, or a piece of split cane, or simply a long brush is also useful in this way, and it is slightly more versatile, because although it has to be held to show a vertical, it can be used for the horizontal and indeed for any angle useful for the particular pose.

One of the most pleasant stages in drawing is to see it hanging on a wall (Fig 110). To frame a drawing and to be able to view it regularly at some vantage point in your house will give you a detached critical view. Frames can be purpose-made by a framer, or purchased from stores ready-made in certain basic sizes. Lengths of framing can be cut and made up at home, and art suppliers may stock packs containing two sides of a frame, so a complete frame can be made from two packs. These will also need a sheet of glass and some card backing of course. A sheet of chipboard or blockboard can be the base of a sandwich, the drawing placed between it and an identically-sized piece of glass. A minimum of eight L-shaped metal or plastic clips can be screwed to the backing and, coming over the glass, will hold it in place. This type of 'no frame' frame is economic but not suitable for constant moving or handling, for the glass edge is vulnerable.

The drawing itself will be shown to advantage if the frame chosen is about 6in (150mm) larger in each dimension. It should be placed slightly higher than central to look comfortable.

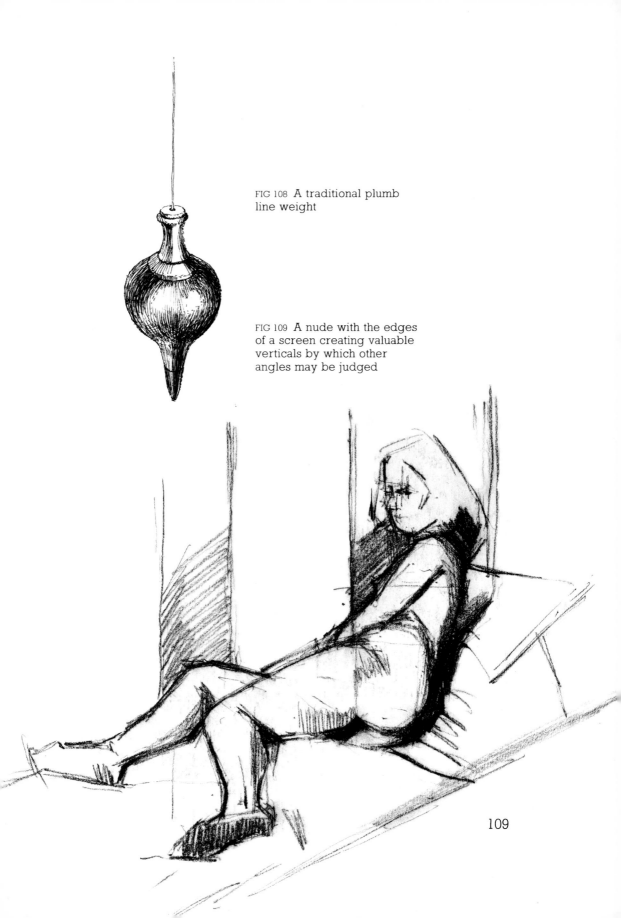

FIG 108 A traditional plumb
line weight

FIG 109 A nude with the edges
of a screen creating valuable
verticals by which other
angles may be judged

109

FIG 110 A drawing in a frame

FIG 111 A drawing mounted on a backing sheet with the addition of a pencil line to add a little richness to the presentation

FIG 112 A turn clip at the back
of a frame. When used instead
of tacks the removal and
replacement of work is greatly
facilitated

If a drawing is laid on a backing sheet, fix it with two tiny pieces of adhesive putty. A line may then be drawn with a pencil, coloured or black, $\frac{1}{2}$in (10mm) from the edge of the drawing. This 'framing' line can do much to enhance the appearance (Fig 111).

Cutting a card mount for your drawing does not merit the great mystique which often seems to surround the subject. A craft knife, with a handle large enough to hold firmly, will make a very crisp cut through special mounting card. Measure your drawing, add 6in (150mm) to each dimension. Mark and cut off this size of mounting card. Then very lightly draw a line 3in (75mm) in from each side, 2$\frac{3}{4}$in (65mm) in from the top and 3$\frac{1}{4}$in (85mm) in from the bottom. Take great care not to over-run at the corners. Holding the knife at a sloping angle to the card, cut along each side in turn. The corners may need a little careful re-cutting to free them. In first attempts your line may wobble, but if you hold your arm straight (moving your body rather than your wrist) and keep practising, you should meet with tolerable success. It may also be worthwhile exploring the range of mechanical cutters which are available.

Whatever method is chosen it really is the drawing which should have all the priority. For the artist constantly at work, the ability frequently to change drawings in their frames is an advantage and it is quite possible if you have some standard sizes of paper and mounts. The use of turn clips rather than tacks at the back makes for greater simplicity (Fig 112).

The fascination of life drawing is its never-ending repetition, yet in so many subtle ways it is never quite the same (Fig 113). It's always the next model whom it is even more worthwhile to draw, and the next drawing which will capture more of that fascinatingly elusive character (Fig 114).

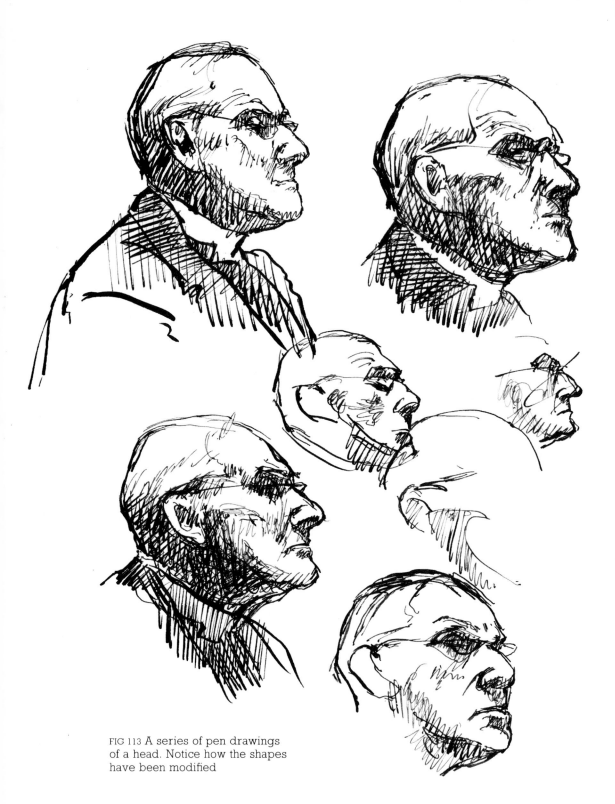

FIG 113 A series of pen drawings
of a head. Notice how the shapes
have been modified

112

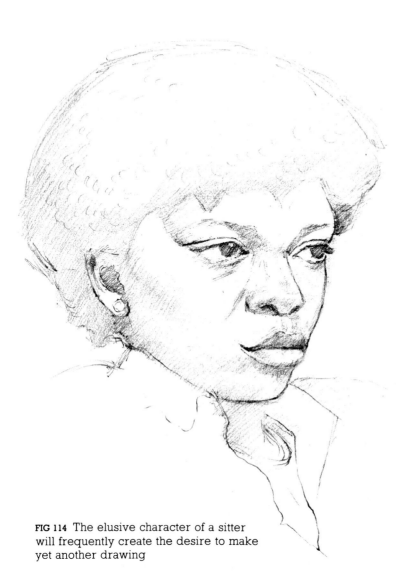

FIG 114 The elusive character of a sitter will frequently create the desire to make yet another drawing

GLOSSARY

Blockboard
A board made of blocks of wood sandwiched between two outer layers of sheet wood

Boundary
The edge of a limb or body which the artist may describe as a line or a change of tone

Brush
Related to drawing it should maintain a crisp spring. If used for wash it should be large and broad. A Chinese calligrapher's brush can be used successfully for both purposes

Canvas
Canvas stretched on a wooden frame and prepared for painting. It is also a very broad term describing any support on which an artist may work

Chalk
Dry sticks of pigment for drawing. The degree of hardness can vary considerably to a point where, when extremely soft, they might be called pastels

Characteristic
Obvious shapes, tones or colours which, to the artist, seem fundamentally important

Charcoal
Traditionally made of partly burnt willow twigs, size and hardness can

vary. Rich, velvet blacks are obtainable, but need considerable fixing

Chipboard
A board made of compressed wood chips. Only use special chipboard screws, otherwise it may split

Conté
Originally the name of the creator of an early form of pencil; now a respected firm of manufacturers whose name has become synonymous with coloured chalks and pencils, the warm, brown colours of which are classics of their type

Craft knife
A wide variety is available which have replaceable blades. For mount cutting the handle should be large; for sharpening pencils the blade should be retractable – for safety

Cross hatching
The technique of obtaining an area of tone from lines drawn closely together and, by stages, lying at different angles to one another

Dowel
Wood rods obtainable in a range of diameters

Draughtsman
One who draws. A broader term than that usually associated with more

technical drawings

Easel
H-base
A heavy studio support for large works. Four castors on its H-shaped base give limited mobility

Sketching
Lightly made and partly telescopic to facilitate transportation

Tri-point
A heavy easel, providing a firm support on three splayed legs. It can be reduced in size for limited transportation

Eraser
Commonly called a rubber, it should be cleaned before use and if old a dry exterior removed. Putty rubbers are pliable and remove by a patting action

Felt-tip pen
Effective and bold, but some types contain inks which fade

Fixing
The application to a drawing, generally by spraying, of a proprietory brand of fine, clear matt varnish to prevent smudging

Form
A summing up of structural fact and interpretive feeling about something three-dimensional

Horizontal
A straight level line running to left and right; it lies at 90 degrees to vertical

Ink
In types used for fountain pens, black tends not to be very dense and some can even look blue. Black drawing ink can be very dense and flow well; ink in cartridges is particularly clean to use. Most inks are not waterproof. Indian ink is dense and sticky; it does not flow easily and is best used with a dip pen – but it is waterproof when dry

Likeness
A quality of recognition which an artist might seek to create in a portrait

Mark
That which an artist might place on a surface. Essentially a combination of artist, material and surface, rather than the subject the mark may describe

Measure
The comparison of parts which may be judged by the use of a pencil, brush or stick held in the hand

Model
A living animal or person who poses in a still position in order to be drawn by an artist. Not to be confused with 'Still life' which refers to a single or group of inanimate objects

Modelling
The description of bumps and hollows by the use of lines, areas of tonal shading or colour changes

Mount
A card surround to a drawing or painting

Mounting card
Card having a fine cake-like texture which is firm but easily cut

Pencil
A drawing instrument containing a core of the pigment which makes a mark, generally surrounded by wood or metal which protects and provides a suitable handling size

Pencil grades
H is hard; HB, hard black; B, black. A 2B is less black than an 8B, which is the softest B commonly obtainable, and which delivers the darkest mark

Pen nib
A metal nib which can be fitted into a holder. When dipped in a bottle of ink, excess liquid should be removed each time by stroking the top of the nib (the convex side) against the edge of the bottle

Perspective
The art of delineating objects in a picture in order to give the same impression of relative positions and

magnitudes when viewed from a
particular point

Plane
A flat surface of infinite size

Pose
The stance or position a model is asked
to adopt while an artist works

Power
When used in reference to a drawing it
suggests clarity of image, strong tonal
contrasts and emphasis on abstract or
compositional priorities

Proportion
The size of one part compared with
another

Rembrandt
Rembrandt van Ryn, 1606–69, born in
Leyden, Holland. Many of his works
show figures in small areas of light in
dark rooms

Self-portrait
A portrait where the artist portrays her
or himself. When only one mirror is
used the image created will be
reversed, i.e. a hair parting which is on
the left will appear as if on the right in
the picture. A second mirror can
correct this but any movement can be
confusing

Shape
Areas or patches created on the flat
surface which interpret the three-
dimensional aspects of the original
figure

Silk screen
A fine material screen, now frequently
synthetic, stretched very tightly on a
wood or metal frame. The image is
created by blocking out chosen areas
to prevent creamy ink passing through,
while the unblocked areas will allow
the ink to repeat the image on a sheet
of paper below the screen

Silver pencils
Usually well made, a variety may be
found in antique shops. They form a
protective container for a traditional

pencil, though only a short length

Sitter
A person who is the subject of an
artist's work. A sitting refers to a
period of time and not the position of
the pose. Thus a sitter could have a
standing pose, the sitting lasting for
one hour

Sketch book
A book suitable for holding in the
hand. When spiral bound, the pages
can be folded totally to the back to
keep the book firm

Slade
The Slade School of Fine Art,
University College London. Founded
by an endowment of Felix Slade in 1871
as both an academic and experimental
school. Past pupils include Augustus
and Gwen John, Sir Stanley Spencer,
David Bomberg and Sir William
Coldstream

Spotlight
Any adjustable light using a bulb with a
reflecting surface which produces a
beam

Sugar paper
A coarse, thick paper available in a
range of colours. Although less
expensive than most other papers,
some colours can quickly fade

Symmetrical
Having parts which are the same and
placed opposite one another. This
regularity is useful to the artist because
irregular parts are seen in contrast

Three-quarter view
To view a person slightly from one
side, i.e. not a totally front or totally
side view

Tone
The degree of lightness or darkness of
any colour

Turn clips
Small metal clips which can be
screwed to the back of a frame to hold
a work in place. For the picture's

removal, they can be turned out of the way

Vertical
Upright, perpendicular, at right angles to horizontal

Wash
A semi-transparent coat of pigment carried in water. Water colour, poster colour, gouache may be used, but some inks may coagulate: trials should be made first. Chinese stick ink – dry sticks which dissolve slowly when rubbed on a wetted surface – is a classic form of wash

Water colour
Fine quality pigment based on gum dissolved by water. Available in small tubes or rectangles (called pans or half pans according to size)

Wax crayons
Very inexpensive, they only mix well with their own kind. Of a large size, the need for sharpening can deter precise use. Ideal for large, bold work and particularly effective on the matt side of brown wrapping paper

Wrapping paper
A tough paper coloured brown or green. The outside, for packaging, is smooth and shiny and not very suitable for drawing, but the back which is matt and finely ribbed can be excellent

FURTHER READING

Ashwin, Clive, *Encyclopaedia of Drawing*, Batsford

Baker, Arthur, *The Calligraphy Manual*, Dryad Press

Ball, Wilfred, *Sketching for Landscapes*, Dryad Press

Ball, Wilfred, *Weather in Watercolour*, Batsford

Croney, John, *Drawing Figure Movement*, Batsford

Furber, Alan, *Layout and Design for Calligraphers*, Dryad Press

Gordon, Louise, *Anatomy and Figure Drawing*, Batsford

Gordon, Louise, *Drawing the Human Head*, Batsford

Jones, Edward, *Painting People*, Batsford

Lancaster, John, *Basic Penmanship*, Dryad Press

Pinter, Ferenc, and Volpi, Donatella, *A Guide to Drawing*, Dryad Press

Woods, Michael, *Starting Pencil Drawing*, Dryad Press

INDEX